Contents

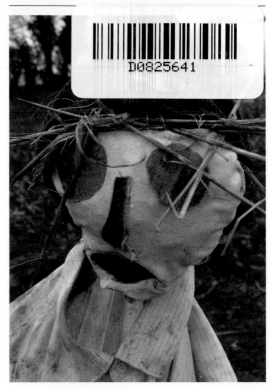

Scarecrow, Hawkwood College, near Stroud,
Gloucestershire, 2005

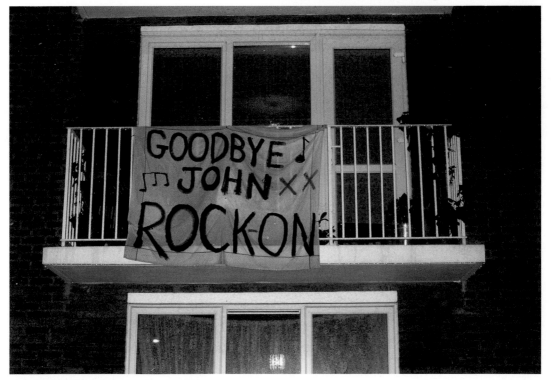

John Peel Tribute, King's Cross, London, 2004

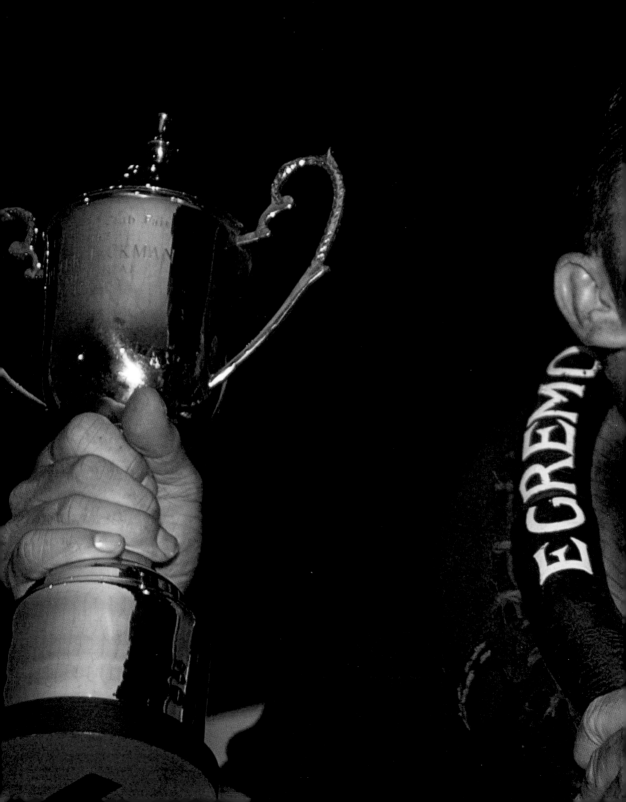

Tommy Mattinson, World Gurning Champion,
Egremont, Cumbria, 2004

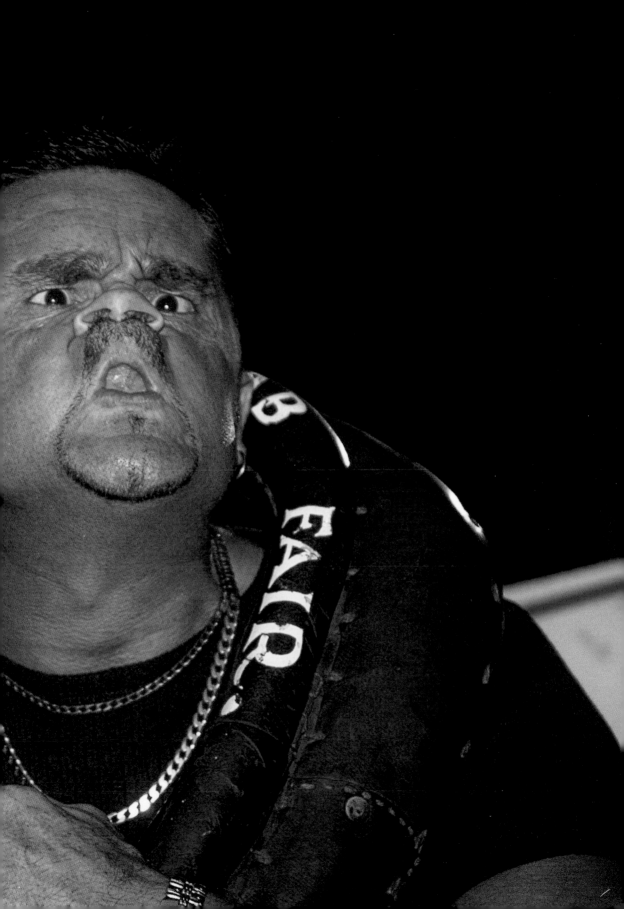

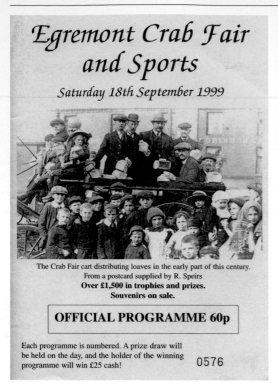

Egremont Crab Fair and Sports

Saturday 18th September 1999

The Crab Fair cart distributing loaves in the early part of this century. From a postcard supplied by R. Speirs
Over £1,500 in trophies and prizes.
Souvenirs on sale.

OFFICIAL PROGRAMME 60p

Each programme is numbered. A prize draw will be held on the day, and the holder of the winning programme will win £25 cash!

0576

Egremont Crab Fair Official Programme

Spoils after the Parade of the Applecart, 2004

Egremont Crab Fair, Cumbria

An astonishing amount of events go to make up the week long Crab Fair at Egremont, Cumbria. It was established in 1387 and includes: Fell Racing, Cumberland and Westmoreland Wrestling, Crowning of the Carnival Queen, Horse Trials, Parade of the Applecart, Cycle Races, Climbing the Greasy Pole, Egg Throwing, Hound Trails, Vegetable Shows, Vintage Car Rally, Dog Shows, Ferret Roulette, Talent Contest, Hunting Song Competition, Wheelbarrow Racing, Pipe Smoking Competition and the World Gurning Championships.

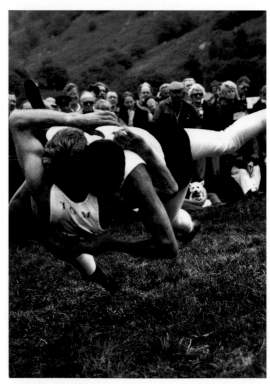

Cumberland and Westmoreland Wrestling
(photo: Mike Dawson)

Parade of the Applecart, 2004

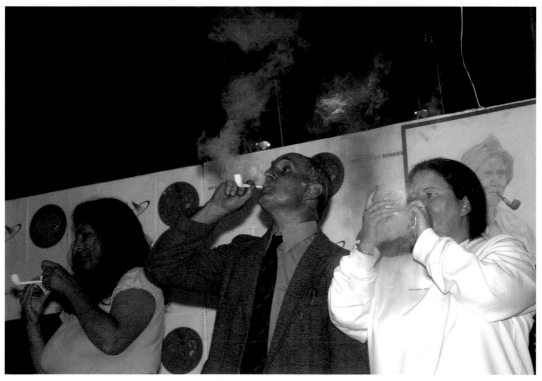

Pipe Smoking Competition, 2004

<p align="center">Allcomers are welcome to</p>

Riding the Fair
<p align="center">and the</p>

Olde Gymkhana

<p align="center">All equestrian events are generously sponsored by local businesses.</p>
<p align="center">Held at St Bees Road, Egremont, with the kind permission of Mr John Spedding of 'Howbank'</p>
<p align="center">All Equipment: Cumberland Foxhounds Branch of the Pony Club</p>
<p align="center">**Please note: The following classes are to be held over two days**</p>
<p align="center">A points championship will be in operation with a trophy to be presented for the highest points total over the two days</p>
<p align="center">(excluding classes 9, 10, 26. 27. 28, 29)</p>

《》

Saturday 11th September 1999

PONY LEAPING (11am start)

Class 1 Pony Warm Up Stakes
 Sponsor: D Watson & Son, the Smithy, Bigrigg
Class 1A Pony Warm Up Stakes for Novices
 This is for riders who have not won a show jumping class. Please be honest, as this is to encourage novice riders.
 Sponsor: Novice Class: BSS, Carlisle Trophy: Novice Class: Dentside Tankard

Class 2 Horse Warm Up Stakes	Class 3 Not Exceeding 13 Hands
Sponsor: Sponsor: Universal Tractor Imports Ltd. **(J. Carr Coulderton)**	**Sponsor: Furness & S Cumberland Supply Assoc.** *Trophy The Rose Southward Trophy*
Class 4 Open Horse (starting at 2'9")	Class 5 Above 13 Hds, not exceeding 14.2 Hds
Sponsor: Watson Studholme(paper bedding manufacturer) *Trophy: The Michael Sice Memorial Trophy*	**Sponsor: Ken Hope Plant Hire, Carlisle** *Trophy: The Rose Southward Trophy*
Class 6 Junior Bareback Scurry (14 yrs & under)	Class 7 Senior Bareback Scurry
Sponsor: S J Tunstall Ltd Construction Consultant *Trophy: Dentside Stables Trophy*	**Sponsor Edmundsons Electrical, Workington** *Trophy: The Stirling Cabs Shield*

Class 8 Double Dash (order to be drawn)
Sponsor: Robert Benson Luxury Coach Hire (Airport Services)

《》

Saturday 18th September 1999

<p align="center">Horse restricted to one class in section A and one in section B</p>

Section A TURNOUT

<p align="center">Champion & Reserve awarded</p>

Class 1 Lead Rein 8 Years & under	Class 2 12 years and under
Sponsor: Hewden Plant Hire, Whitehaven	**Sponsor: Mitch Graham Travel (Airport Services)**
Class 3 13 to 17 years	Class 4 18 years and over
Sponsor: Watson Studholme & Son, Aspatria Shredded paper bedding manufacturers	**Sponsor: Four Legged Friends, Egremont** *Trophy: K & E Joyce Rose Bowl*

Section B EQUITATION

<p align="center">Champion & Reserve awarded</p>

Class 5 Lead Rein 8 Years & under	Class 6 12 years and under
Sponsor: St Bridgets Lane Veterinary Centre *Trophy: Dentside Stables Trophy*	**Sponsor: McAllister Garage Services, Egremont**

Programme Pages, Crab Fair, 1999

Class 7 13 to 17 years	Class 8 18 years and over
Sponsor: Thomas Graham & Sons, Egremont	**Sponsor:** Cumbrian Mortgage Services (K Brown)
Trophy: *Egremont Crab Fair Trophy*	Tel 01900 602467
	Trophy: *Stirling Cabs Shield*

Classes 1, 3, 5 & 7 to start at 9.00am

The *Jenkinson Cup* will be awarded to the 'Supreme Champion' of the Fair.
(Kindly presented by Mrs Mary Jenkinson of Egremont)

The *Whitecroft Cup* will be awarded to the 'Reserve Supreme Champion' of the Fair
(Kindly presented by Mr & Mrs Stephenson of Whitecroft House, Egremont)

«()»«()»«()»«()»«()»«()»«()»«()»«()»«()»«()»«()»«()»«()» «()»«()»«()»«()»«()»«()»«()»«()»«()»«()»«()»«()»«()»«()»«()»«()»«()»«()»«()»

𝕽iding the 𝕱air

Generously sponsored by **Ben & Jerry's Ice Cream**

11.00am	War Memorial	One minute of silence
		Hunting horn blown by Stan Ellwood
11.05am	Supreme Championship Presentations	
11.10am	PROCESSION following the St. George's flag	
	(it is traditional to have a fiddler on horseback leading the procession)	

Route: Main Street, Jubilee Garage, Smithfield, Whitegate, Castle Croft, Bookwell, Market Place.
Concluding at the Royal British Legion which is kindly hosting the Riding of the Fair.

Commemorative Rosettes will be presented to all horses/ponies that complete the 'Riding of the Fair'

«()»

𝕺lde 𝕲ymkhana

Commencing approx. 1.00pm

Class 9 Veteran Horse/Pony 14 yrs & over	Class 10 Cob Class (judged on Presentation & Co-ordination)
To have completed the Riding of the Fair	
Sponsor: Saddle Tramps	**Sponsor Saddle Tramps**

Class 11 Pony Leaping, 8 yrs and under lead rein	Class 12 Pairs Equitation – Open
Sponsor: BSL, Workington	**Sponsor: Ken Hope Plant Hire, Carlisle**
Trophy: *Egremont Pet Shop & Aqua Centre*	*To be judged on overall appearance and a synchronous show*

"HANDY PONY"

Class 13 Lead rein, 8 years and under	Class 14 Junior 12 years and under
Sponsor: Linden Industrial, Workington	**Sponsor: Maurice Bewley Electrical Contractor**

Class 15 Senior 13 years and over
Sponsor: D Birkett Fencing, Rowrah

The *Dentside Tankard* for the fastest time of the day

PONY SPORTS

The novelty classes will run alongside the Pony Sports.
Points trophies kindly donated by Mr Robert Scott, Seaton, Workington

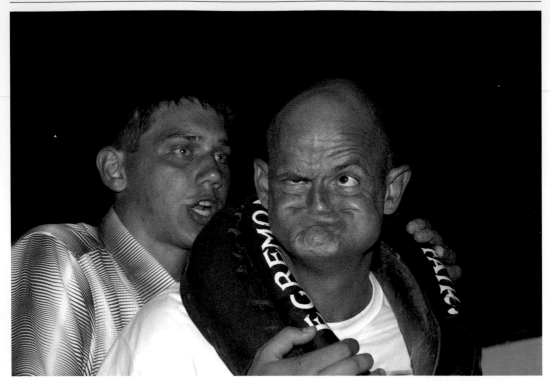

Clive from Cheshire, 2004

World Gurning Championships

The highlight of the Egremont Crab Fair is the World Gurning Championships that take place in the village hall. The derivation of the competition, like many other calendar events, is not entirely clear. It may have something to do with imitating the village idiot or pulling faces after taking a bite out of a crab apple.

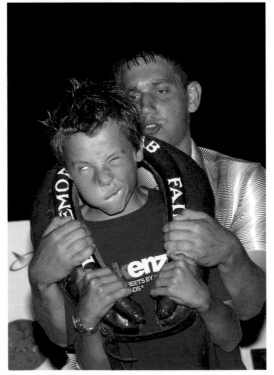

Children's Gurning Competition, 2004

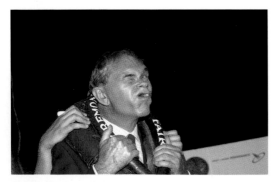

Gordon Mattinson, 2004

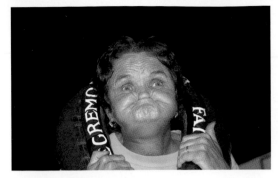

Ann Woods, 2004

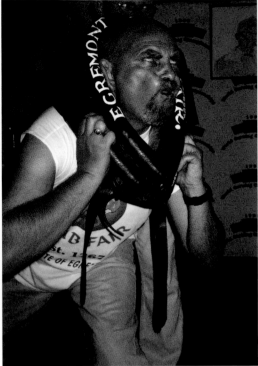

Peter Jackman, 1999

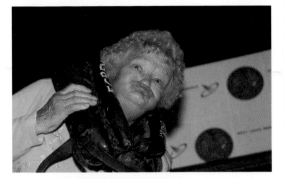

Kath Taylor, Women's Champion, 2004

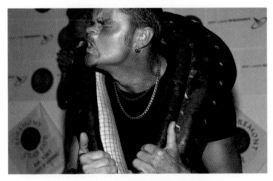

Tommy Mattinson, World Gurning Champion, 2004

'I started gurning when I was ten years old, and entered my first competition when I was fourteen. Although it is just a bit of fun, it is competitive and I do get nervous on the night. I have to train for a week beforehand. My father is ten times champion and like me is very competitive. I think he is worried that I am going to beat his record. It is amazing what opportunities gurning has given me. I once spent a week in Hollywood when I appeared as a guest on the *Jay Leno Show*.'
— Tommy Mattinson

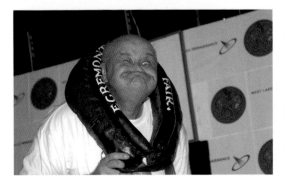

Alex Woods, 2004

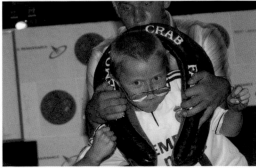

Children's Gurning Competition, 2004

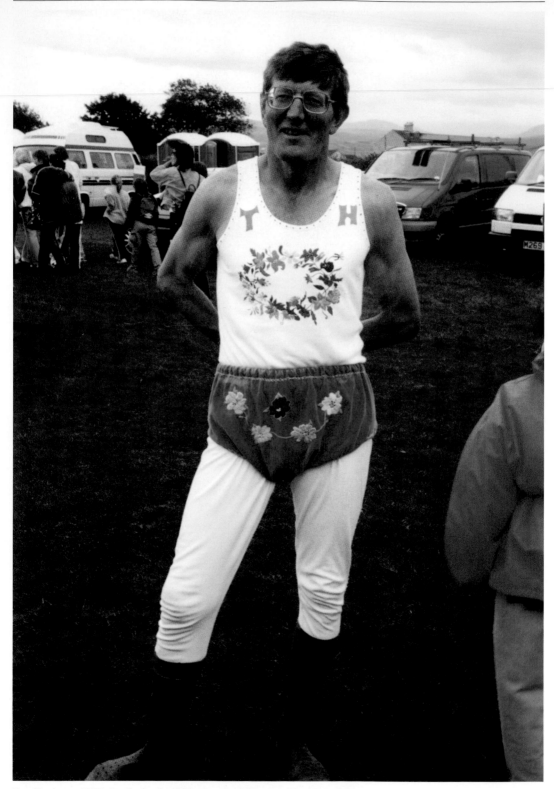

Tom Harrington MBE, Cumberland and Westmoreland Wrestling Champion, 1999

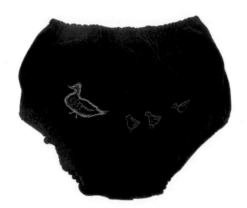
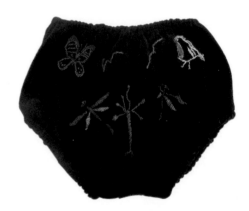

Cumberland and Westmoreland Wrestling Costumes
(courtesy Richard Fox)

Cumberland and Westmoreland Wrestling Costumes

Cumberland and Westmoreland wrestling costumes are often embroidered and the designs are usually associated with nature. Prizes are given for the best examples and are not just decorative as they are often worn during the wrestling competitions themselves.

Bastille Day Performance,
Maison Bertaux, London

Most years the staff of this renowned Soho patisserie celebrate Bastille Day (July 14) with a street theatre performance condensing the French Revolution into a fifteen minute production, that is repeated throughout the day.

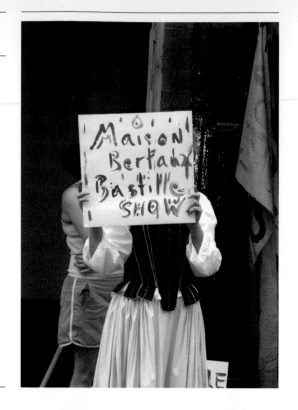

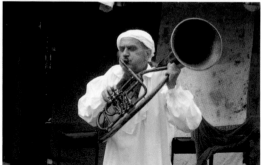

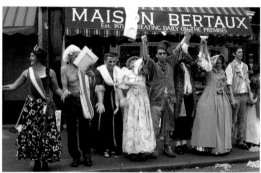

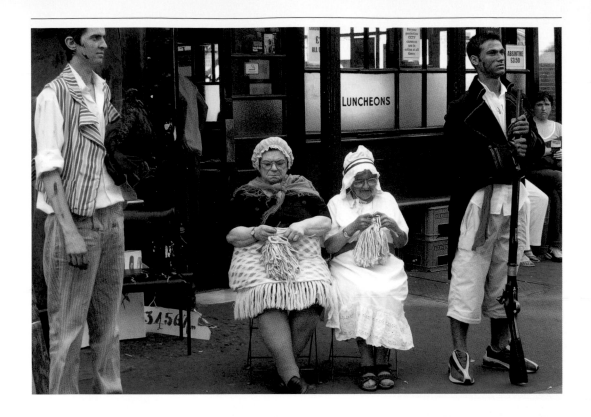

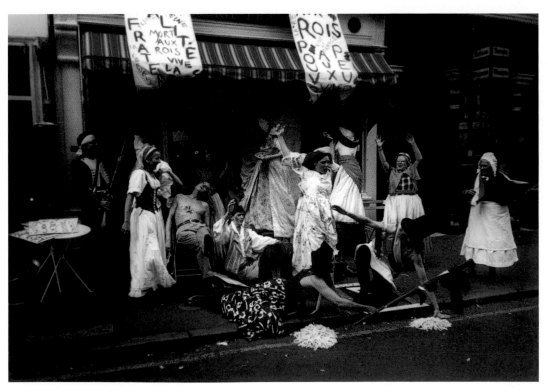

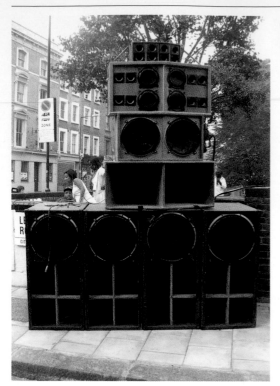

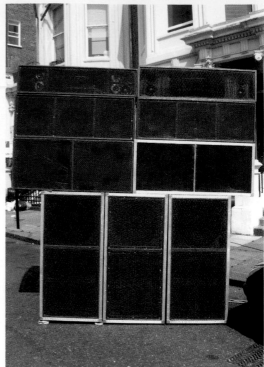

Notting Hill Carnival, London

The Notting Hill Carnival started in 1964 and today is the largest of its kind in Europe, often attracting more than a million visitors over the August Bank Holiday weekend. The carnival was originally organised to bring local black and white children together as well as serving to celebrate the culture of local Caribbean residents in the face of racism and poor living conditions.

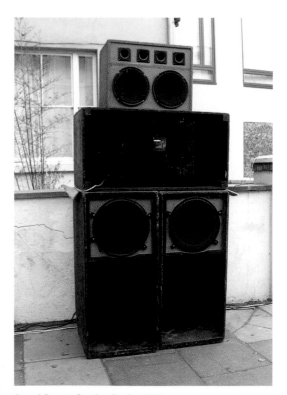

Sound System Speaker Stacks, 2003

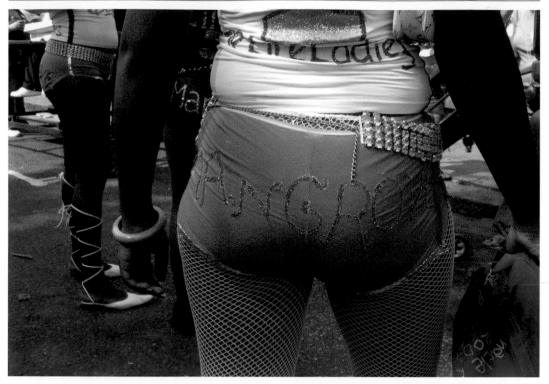

Mangrove Carnival Troupe Pants, 2003

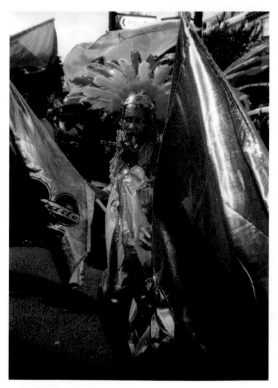

A Children's Day Costume, 2000

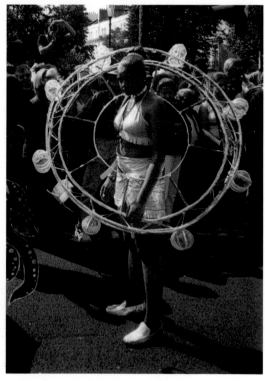

London Eye Costume on Children's Day, 2000

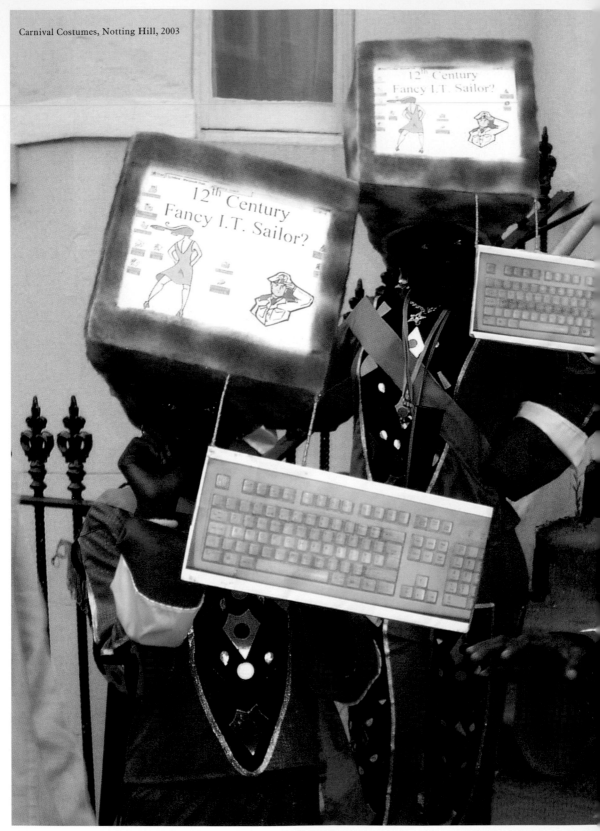

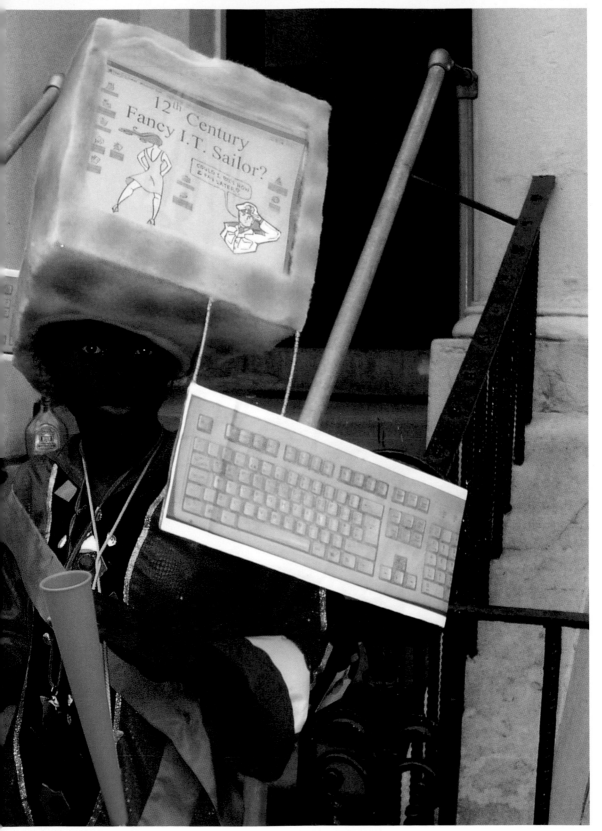

The Parade of Beasts, Banbury

The Parade of Beasts is a unique convention of animal costumes and figures connected with Morris sides, and traditional events and plays from all over the UK. There are competitions and events based around the hobby horse theme as well as the opportunity to see some remarkable creatures which rarely come together. It has taken place each July since 1999 in this town centre.

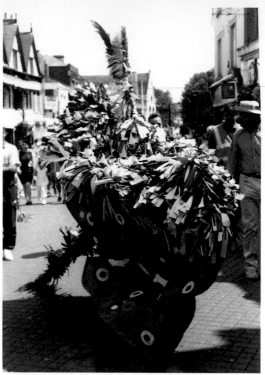

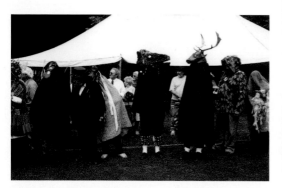

The Parade of Beasts, Banbury, Oxfordshire, 2000

The Town Horse of Minehead at Banbury, 2000

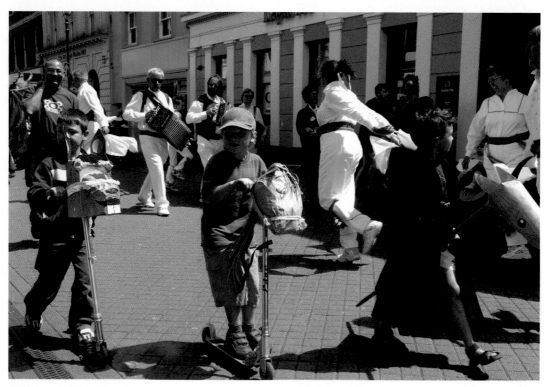

Children with Hobby Horse Scooters, 2004

Hunting the Earl of Rone, Combe Martin

Hunting the Earl of Rone is an event in Combe Martin, North Devon which involves the search, capture and parading of the legendary Earl of Rone. Tradition says that a real Earl of Tyrone, fleeing Ireland four hundred years ago, was shipwrecked on the beach at Combe Martin and later found in a nearby forest.

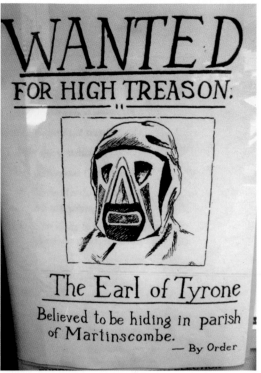

WANTED FOR HIGH TREASON.

The Earl of Tyrone

Believed to be hiding in parish of Martinscombe. — By Order

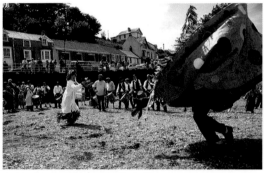

Hobby Horse, Hunting the Earl of Rone
(photo: Doc Rowe)

Wanted Poster, 2004

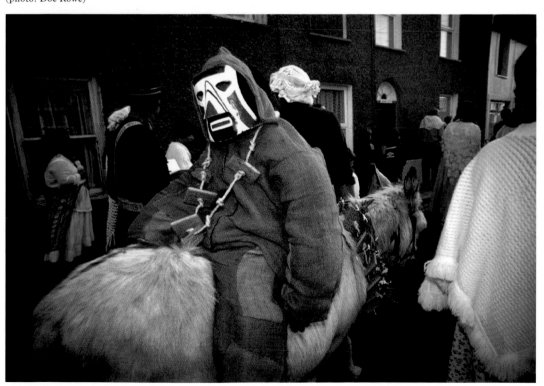

The captured Earl is paraded and taken down to the sea (photo: Doc Rowe)

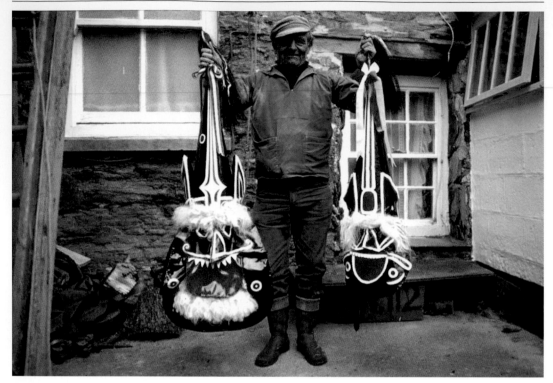

Tommy Morrisey with two 'Oss Masks he painted c. late 1970s

May Day, Padstow

May Day celebrations in Padstow, Cornwall are perhaps the most intense in the country and for many years have featured two parties or mayers following their respective Obby 'Oss (the Old 'Oss and the Blue Ribbon 'Oss) around the town to a distinctive tune played on accordians and drums throughout the day and into the night. It has been known for youngsters to improvise their own Cardboard Obby 'Oss.

Doc Rowe

All the photographs on these pages have been taken by Doc Rowe. He has consistently documented seasonal traditions and events all over the UK for the last forty years and has amassed a huge and invaluable archive of images, film, video and audio recordings. His singular contribution to UK culture has been recognised by a support group set up to assist in the upkeep of his archive.

The Maypole in the Town Square, 2000

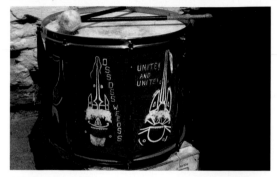

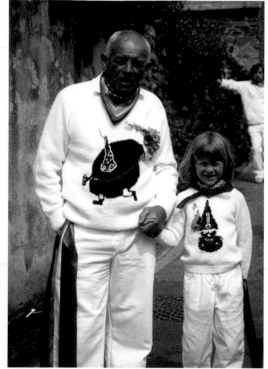

A Padstow Drum

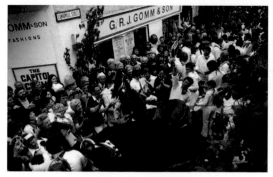

The Old 'Oss and its Party

Old 'Oss Supporters

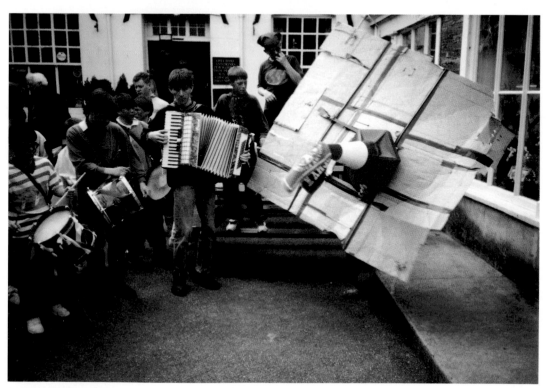

Cardboard 'Oss, Padstow

The Old 'Oss, Padstow, 2000

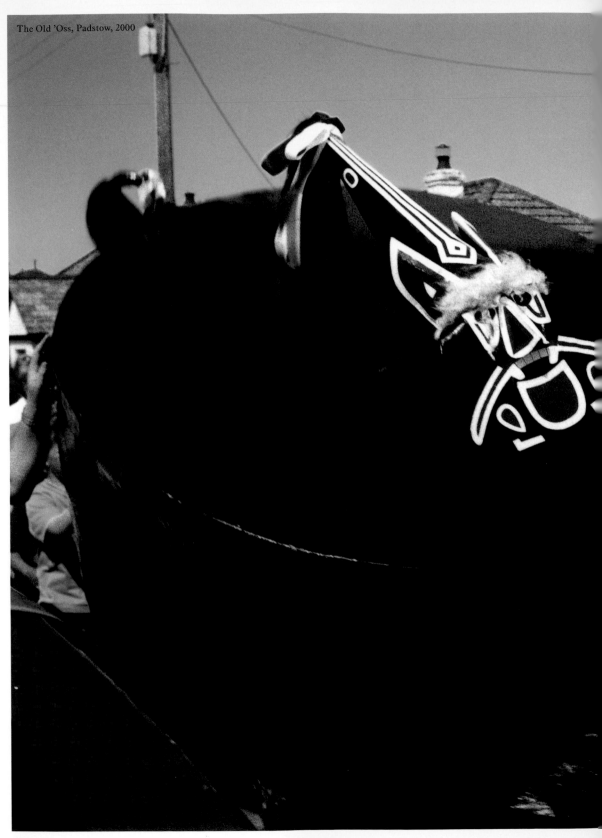

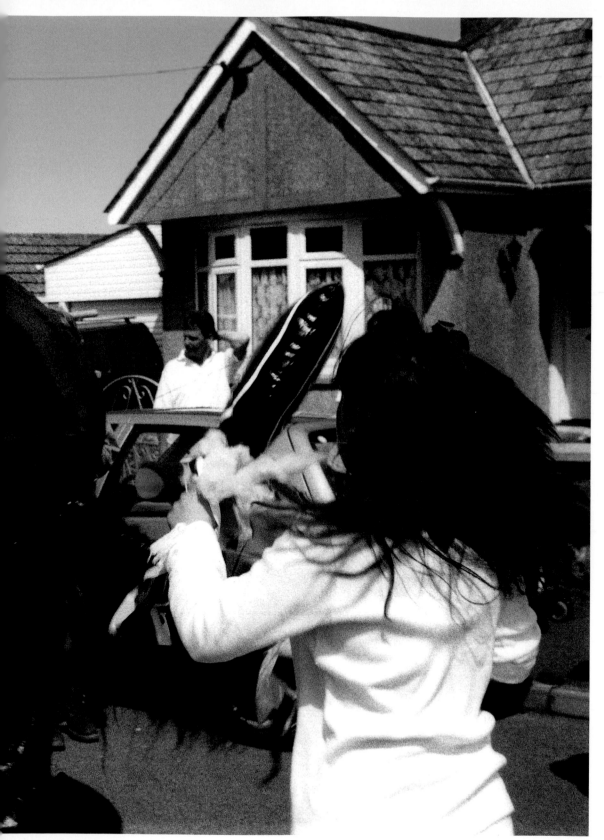

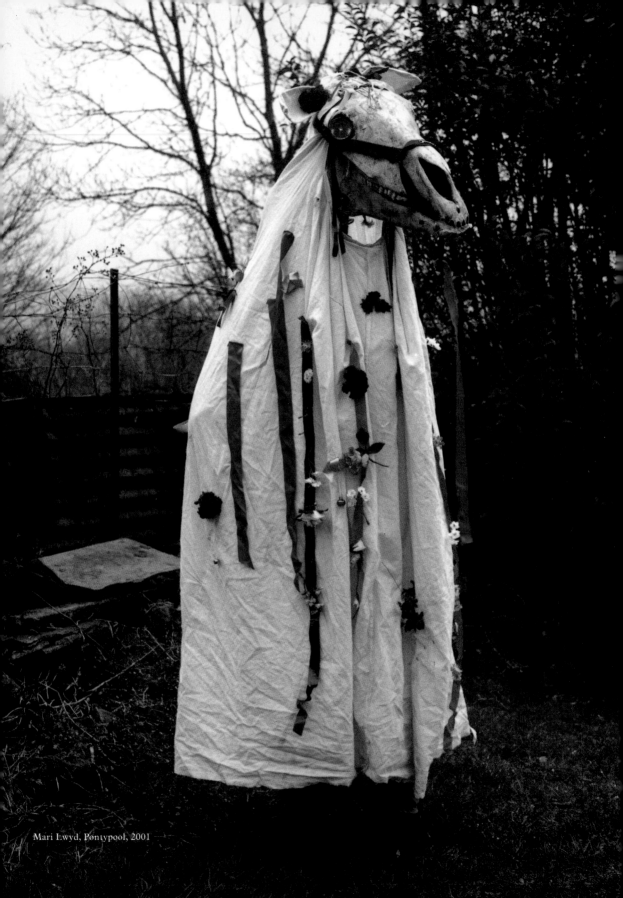

Mari Lwyd, Pontypool, 2001

Mari Lwyd, South Wales

> 'Wel dyma ni'ndiwad
> Gyfellion diniwad
> I ofyn cawn gennad
> I ganu'

A Welsh language custom marking the darkest
days of midwinter, the Mari Lwyd tradition of
parading a horse's skull in pubs and people's
houses continues to this day in South Wales
around New Year. A song is sung and insults
exchanged in a battle of wits known as 'pwnco'.
More recently the money and drink 'collecting'
aspects of the tradition have been replaced by
raising money for charitable oganisations.

Mari in action, Llantrisant, 2000

Mari Lwyd, Llantrisant, 2000

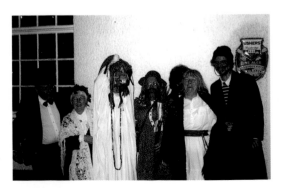

The Mari Party, Llantrisant, 2000

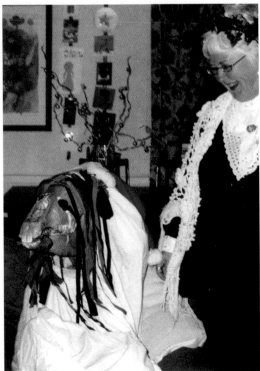

Mari on a House Visit, 2000

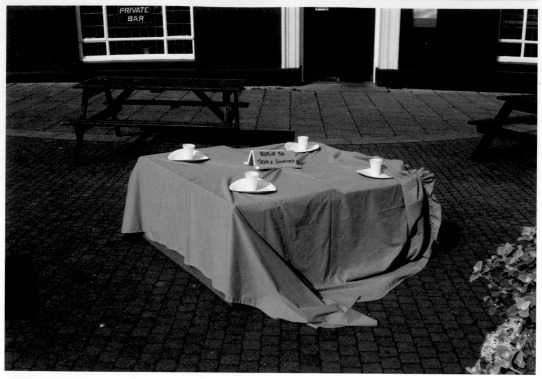

Monkeys' Tea Party Joke, April Fool's Day, Margate, 2002 (photo: Dan Bass)

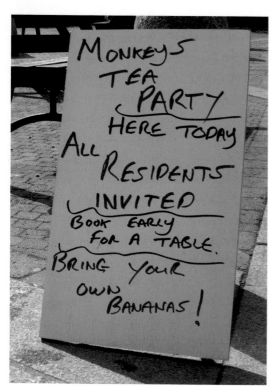

Monkeys' Tea Party, Birchington

In recent years locals in Birchington, Kent, are treated to elaborate April Fool's Day practical jokes. The identity of the jokers is a closely kept secret.

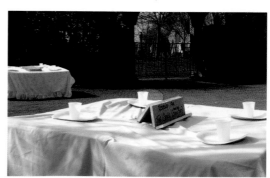

Monkeys' Tea Party Sign, April Fool's Day, Margate, 2002 (photo: Dan Bass)

Monkeys' Tea Party Table Setting, April Fool's Day, Margate, 2002 (photo: Dan Bass)

Tea Cup Sign, Brighton, 2002

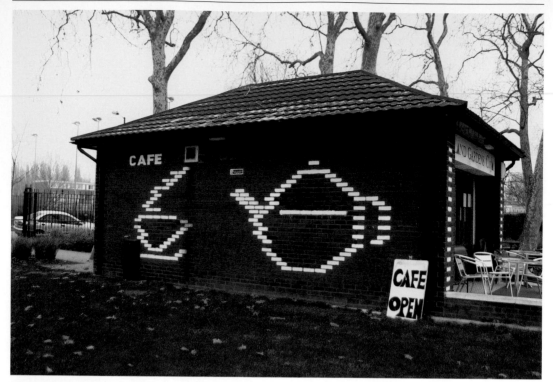

Island Gardens Café, Isle of Dogs, London, 2005

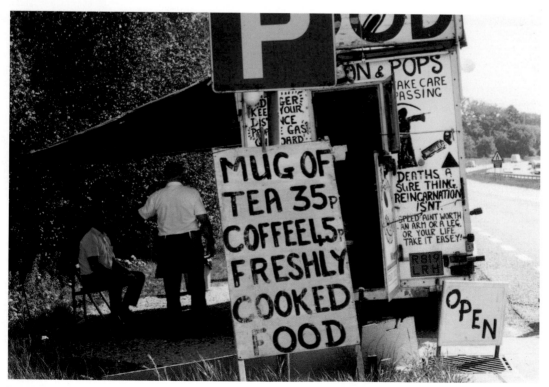

Lay-by Snack Bar offering tea and road safety advice, A21, Sussex (photo: Cathy Ward)

Folk Archive

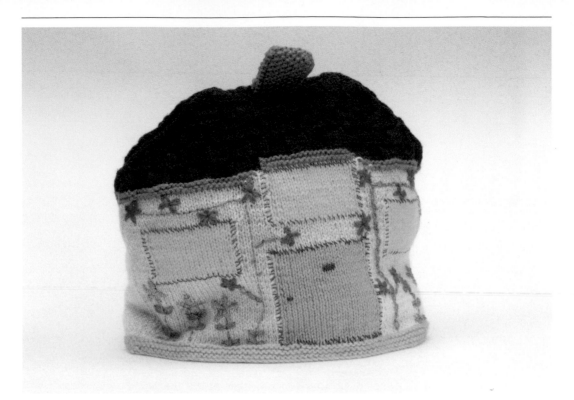

Tea-cosy, Ballymena, Northern Ireland, 1999

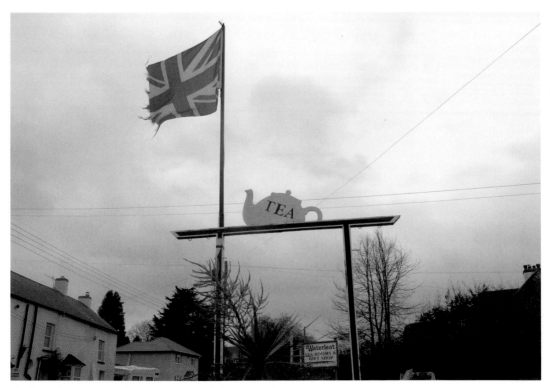

The Southern Cross Guest House, near Sidmouth, Devon, 2004

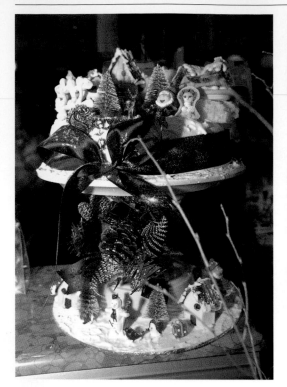

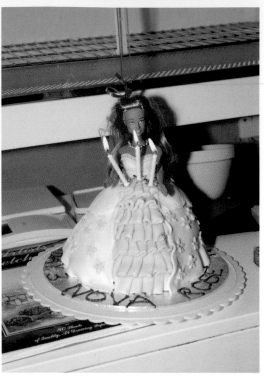

Christmas Cake, Amato Patisserie, Soho, London, 2004

Birthday Cake by Jess, Cornwall, 2004

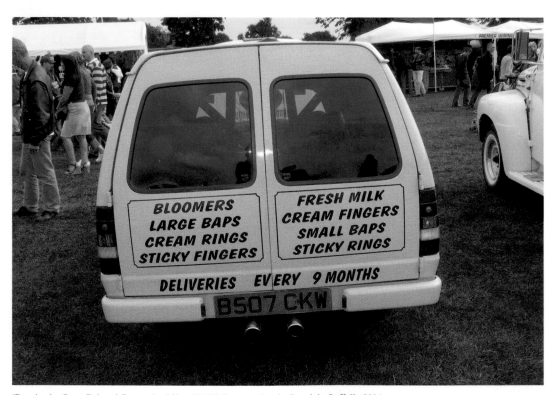

'Bun in the Oven Bakery' Customised Van, NASC Supernationals, Ipswich, Suffolk, 2004

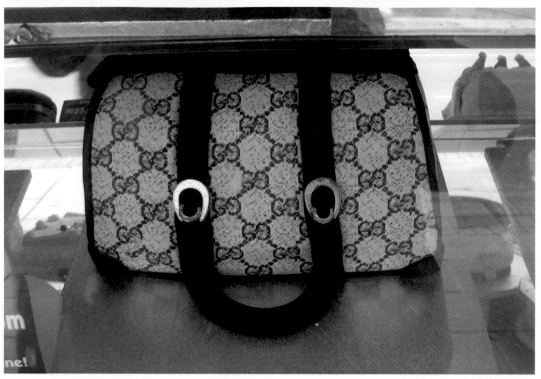

Handbag Cake, Coughlans Bakery, Wimbledon, London, 2005

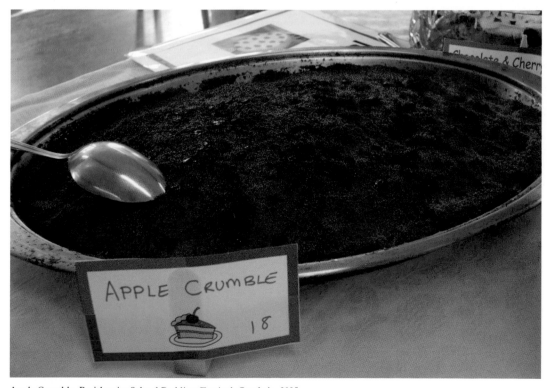

Apple Crumble, Braithwaite School Pudding Festival, Cumbria, 2005

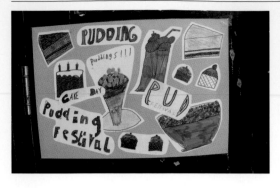 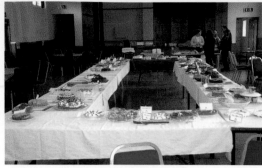

Pudding Festival, Braithwaite, Cumbria

This pudding festival at Braithwaite Village Hall was a fundraising event for the local school. Over one hundred cakes and puddings were donated; entrance was £5 for which you received three helpings of your choice.

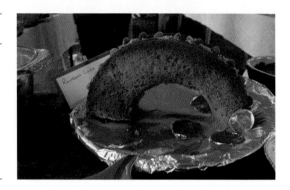

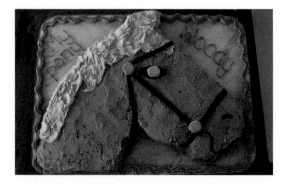

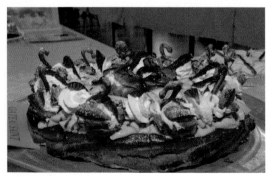

Cakes and Puddings from Braithwaite School
Pudding Festival, Cumbria, 2005

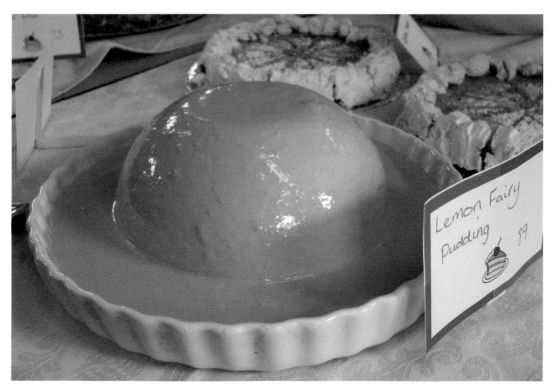

Tea and Coffee Sign, Brighton Pier, 2002

Food Sign, Brighton, 2002

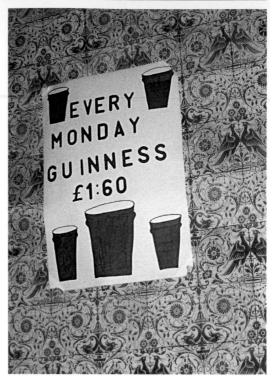

The Dolphin, Hackney, London, 2003

Food Sign, Brighton Pier, 2002

Food Sign, Brighton Pier, 2002

Food Sign by Dave Crossley, South Pier, Blackpool, 2002

Food Sign, Brighton Pier, 2002

Food Sign, Brighton Pier, 2002

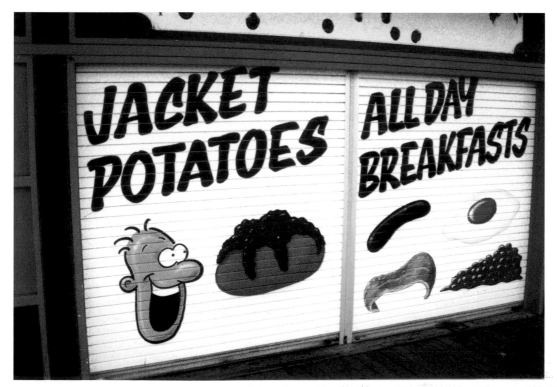

Food Sign by Dave Crossley, South Pier, Blackpool, 2002

Pizza Rut, South Pier, Blackpool, 2005

RUT

PIZZA

JU

CHIPS GRAVY
FISH & CHIPS
SAUSAGE & CHIPS
CHICKEN & CHIPS

HOT
CAN
MILK

Plastic
Handy
Forks

PIZZA CHEESE

BROWN
SAUCE TOMATO
SAUCE

'Pick Your Own' Sign, Evesham, Worcestershire, 2000 (photo: Bruce Haines)

Groceries Sign, Geronway Supermarket, Essex Road,
Islington, London, 2004

Groceries Sign, Geronway Supermarket, Essex Road,
Islington, London, 2004

Groceries Sign, Borne Florists, Hastings, 2005

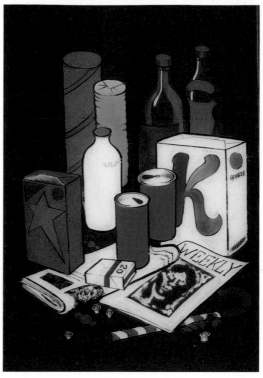

Groceries Sign, Borne Florists, Hastings, 2005

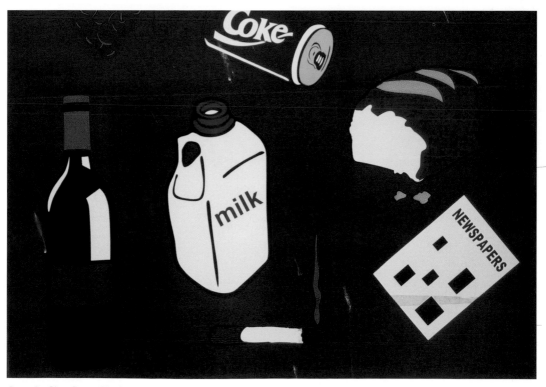

Groceries Sign, Borne Florists, Hastings, 2005

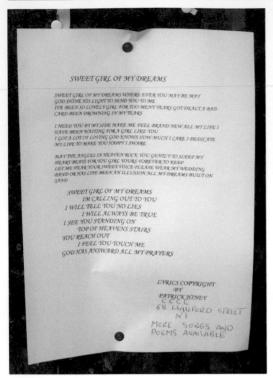

Posted Poem by Patrick Honey,
Essex Road, Islington, London, 2002

Posted Birthday Message, Bath, 2000

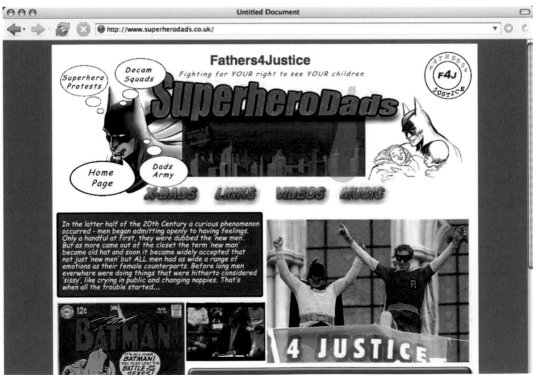

www.superherodads.co.uk, 2005

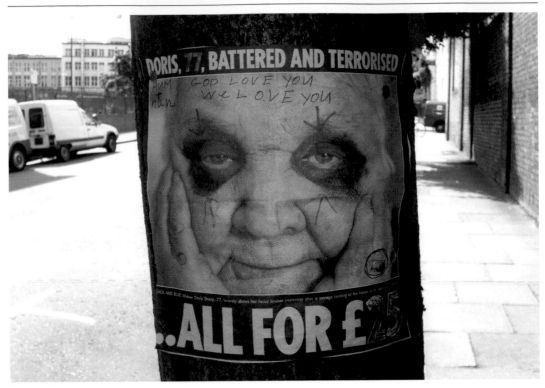

Posted Modified Newspaper Cutting, Finsbury, London, 2004

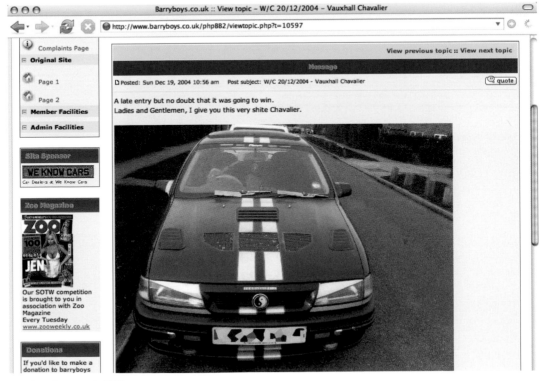

www.barryboys.co.uk, 2005

The World Wide Web

The single most significant new platform for creativity is the Web, with its immediacy and its democratic ability to reach worldwide audiences. It is a limitless platform for enthusiasts, pressure groups and people who just want to show the world what they do or like or hate.

www.clownsinternational.co.uk, 2005

www.brian-sewell.com, 2005

www.deter.org.uk, 2005

www.derelictlondon.com, 2005

www.cloudappreciationsociety.org, 2005

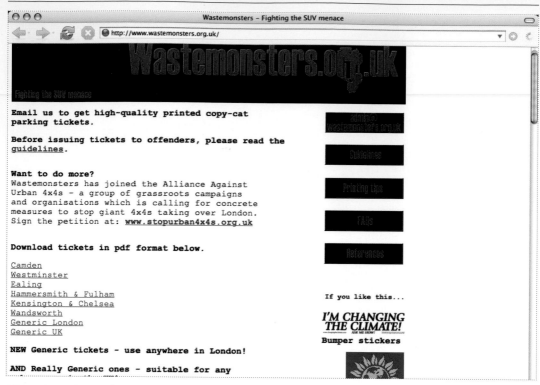

Wastemonsters – Fighting the SUV menace

http://www.wastemonsters.org.uk/

Wastemonsters.org.uk

Fighting the SUV menace

Email us to get high-quality printed copy-cat parking tickets.

Before issuing tickets to offenders, please read the guidelines.

Want to do more?
Wastemonsters has joined the Alliance Against Urban 4x4s - a group of grassroots campaigns and organisations which is calling for concrete measures to stop giant 4x4s taking over London. Sign the petition at: **www.stopurban4x4s.org.uk**

Download tickets in pdf format below.

Camden
Westminster
Ealing
Hammersmith & Fulham
Kensington & Chelsea
Wandsworth
Generic London
Generic UK

NEW Generic tickets - use anywhere in London!

AND Really Generic ones - suitable for any

admin@wastemonsters.org.uk

Guidelines

Printing tips

FAQs

References

If you like this...

I'M CHANGING THE CLIMATE! ASK ME HOW!
Bumper stickers

www.wastemonsters.org.uk

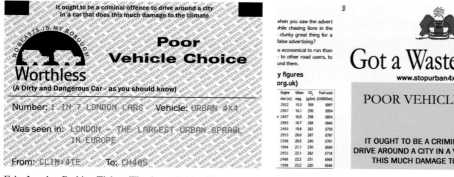

It ought to be a criminal offence to drive around a city in a car that does this much damage to the climate

NO BEASTS IN MY BOROUGH

Poor Vehicle Choice

Worthless
(A Dirty and Dangerous Car - as you should know)

Number: 1 IN 7 LONDON CARS Vehicle: URBAN 4X4

Was seen in: LONDON - THE LARGEST URBAN SPRAWL IN EUROPE

From: CLIM:4TE To: CH405

Fake London Parking Ticket: Wandsworth (detail)

when you saw the advert
while chasing lions in the
clunky great thing for a
false advertising?
is economical to run than
- to other road users, to
und them.

y figures
org.uk)

Engine size (cc)	Urban mpg	CO₂ (g/km)	Fuel costs (£/6000mi)
2922	15.3	309	£897
2967	16.1	290	£854
2497	16.5	298	£854
2995	16.7	288	£846
2493	19.8	262	£758
2953	20.0	287	£787
2398	20.5	240	£701
1994	21.1	230	£668
2953	22.1	262	£718
2488	22.2	231	£668
1998	23.2	220	£646

Got a Wastemonster

www.stopurban4x4s.org.uk

POOR VEHICLE CHOICE

IT OUGHT TO BE A CRIMINAL OFFENCE TO DRIVE AROUND A CITY IN A VEHICLE THAT DOES THIS MUCH DAMAGE TO THE CLIMATE

Fake London Parking Ticket: Westminster (detail)

THIS RUNABOUT CONTRIBUTES TO

POOR VEHICLE CHOICE
A Dirty and Dangerous Car
(as you should know)

CONGESTION AND ASTHMA

Number: 1 in 7 london cars
Vehicle: Urban 4X4

Was seen in: London - the largest urban sprawl in Europe

By a concerned citizen.
From: CL:1M:ATE
To: CH:A0:5

Fake London Parking Ticket:
Kensington and Chelsea (detail)

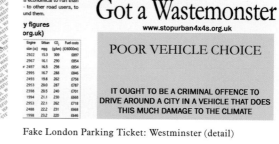

Do you want car-makers to improve safety and fuel economy?

Join the campaign
Re-use this ticket on another 'offender' and see
WWW.STOPURBAN4X4S.ORG.UK
WWW.WASTEMONSTERS.ORG.UK
for more information on what you can do to help.

Haveathink inFuture
Choking our community

Fake London Parking Ticket:
Hammersmith and Fulham (detail)

Wastemonsters

Wastemonsters is a protest organisation and website dedicated to targeting drivers of large wasteful cars such as 4×4s by giving out fake parking tickets with their green message on. They offer these tickets complete with spoof local council logos as freely downloadable files to print out and issue by any interested party.

Carbon

IT OUGHT TO BE A CRIMINAL OFFENCE TO DRIVE AROUND IN A CAR THAT DOES THIS MUCH DAMAGE TO THE CLIMATE

Poor vehicle choice (urban 4x4)
(A dirty and dangerous car - as you should know)

Number: 1 in 7 LONDON CARS
Vehicle: URBAN 4X4
Was seen at location: LONDON - THE LARGEST URBAN SPRAWL IN EUROPE

By a concerned citizen.
From: CL:1M:ATE To: CH:AO:5
On: YOUR/CONSC/ENCE

Signature of car manufacturer:

Whose false advertising led you to believe you needed a 3-ton off-roader to:
GET TO THE GYM / TAKE YOUR KIDS TO SCHOOL / COMMUTE TO A BUSINESS PARK / TREK TO HOMEBASE ON A BANK HOLIDAY*

*deny if appropriate

IMPORTANT:
Only 5% of 4x4s are ever taken off road.
Driving a 13 mpg 4x4 rather than an average 25 mpg car for a year will waste more energy than:
- leaving the fridge door open for 7 years
- leaving the TV on for 32 years
- leaving the bathroom light on for 34 years.

A third of CO$_2$ emitted into the atmosphere by human activity comes from road vehicles.

Do not pay now.
See **www.newscientist.com/hottopics/climate** for how our children and grandchildren will pay for our dependence on fossil fuels.

We've got it wrong!
Do you feel you have been targeted unjustly? Are you sick of your 4x4?
Has your vehicle been converted to use electricity or hydrogen?
Do you want car makers to improve safety and fuel economy?

JOIN THE CAMPAIGN
Re-use this ticket on another 'offender' and visit www.wastemonsters.org.uk and www.stopurban4x4s.org.uk for more about what you can do to help.

Conned?
Be honest with yourself. You got a bit overexcited when you saw the advert where the shiny 4x4 dodges Himalayan rockfalls while chasing lions in the Serengeti. But now you've been trying to park the clunky great thing for a while, don't you feel like suing the manufacturer for false advertising?

In reality, urban 4x4s handle very poorly, are far less economical to run than ordinary family cars, and are far more dangerous - to other road users, to the people inside and to the health of everyone around them.

UK Government fuel economy figures (from www.vcacarfueldata.org.uk)

Make & Model	Engine size (cc)	Urban mpg	CO$_2$ (g/km)	Fuel costs (£/6000mi)	Make & Model	Engine size (cc)	Urban mpg	CO$_2$ (g/km)	Fuel costs (£/6000mi)
Range Rover	4398	12.2	389	£1,129	Volvo XC90	2922	15.3	309	£897
Landrover Discovery	3950	12.3	397	£1,162	Ford Maverick	2967	16.1	290	£854
Porsche Cayenne	4511	12.9	378	£1,091	Landrover Freelander	2497	16.5	298	£854
Toyota Landcruiser	4664	13.1	378	£1,097	Lexus RX300	2995	16.7	288	£846
Isuzu Trooper	3494	13.2	355	£1,045	Suzuki Grand Vitara	2493	19.8	262	£758
Mercedes ML500	4966	13.8	350	£1,018	Nissan Patrol	2953	20.0	287	£787
VW Toareg	4172	13.9	355	£1,028	Mitsubishi Outlander	2378	20.5	240	£701
Audi Allroad Quattro	4172	14.1	331	£958	Subaru Forester	1994	21.1	230	£668
Mitsubishi Shogun	3497	14.2	339	£987	Nissan Terrano	2953	22.1	262	£718
Vauxhall Frontera	3165	14.3	344	£992	Nissan X-Trail	2488	22.2	231	£668
BMW X5	4799	15.1	324	£940	Honda CR-V	1998	23.2	220	£646
Mercedes ML-320	3199	15.2	324	£940	Ford Mondeo 2.0i	1999	25.0	190	£550
Jeep Cherokee	3700	15.2	318	£905	SMART	1332	38.2	138	£403

The safety myth
Many people buy a taller vehicle to feel safe on the road. However, urban 4x4s are oversized and badly designed, making them a danger to their passengers and to other road users. The risk of a fatal rollover crash is about twice as high for a 4x4 as for an ordinary car. The height of 4x4s also makes them lethal in accidents with smaller vehicles. In a side-impact collision with a 4x4, a car driver is around 4 times more likely to be killed than if they were hit by another car.

Funny weather lately?
Don't believe everything you hear about climate change. The truth is, it's already here. Recent worldwide heatwaves, forest fires, violent storms and floods are exactly in line with predictions made by climate scientists at the Kyoto summit back in 1997. Every extra gallon of fuel used by your urban 4x4 puts 9 kilograms of carbon dioxide into the atmosphere.

My little Harry's got asthma too
Ground-level pollution from 4x4s is even worse. They can emit twice as much carbon monoxide, hydrocarbons and nitrogen dioxide than passenger cars. These chemicals cause ozone and other pollutants to build up around cities, leading to poor air quality and dangerous smog.

HOW TO CHANGE THINGS FOR THE BETTER
BY WALKING
A quarter of car journeys cover less than 2 miles. Walking the same distance burns off the calories in two chocolate biscuits. Having more pedestrians around also helps to reduce street crimes, such as burglaries and muggings.
BY CYCLING
Cycling from place to place is often quicker and more convenient than driving, and is far better for you and the city air. Campaign for more cycle lanes in your area if there aren't enough.
BY CATCHING THE BUS
There are loads more buses in London these days and, unlike in the car, you can catch up on work or some reading. As with walking, the busier the bus is, the safer everyone feels.
SHARE A LIFT
If the bus doesn't go your way, why not organise a car pool with other parents from your child's school or colleagues who live nearby? It's friendly and saves fuel, congestion charges and time for everyone.

To me the question of the environment is more ominous than that of peace and war... I'm more worried about global warming than I am about any major military conflict.

Hans Blix, Chief UN Weapons Inspector in Iraq
16 March 2003

Wastemonsters Downloadable Fake Parking Ticket (with altered Camden Council logo)

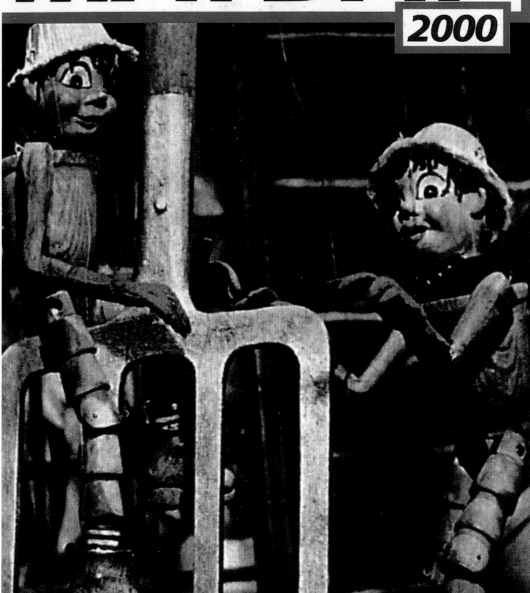

MAYDAY 2000

This is not a protest...

Guerrilla Gardening Leaflet, A Day of Actions in Central London that culminated in the turfing of the road outside Parliament, London, 2000

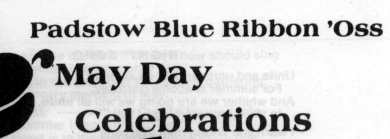

Padstow Blue Ribbon 'Oss
May Day Celebrations

An abridged copy of the

May Song

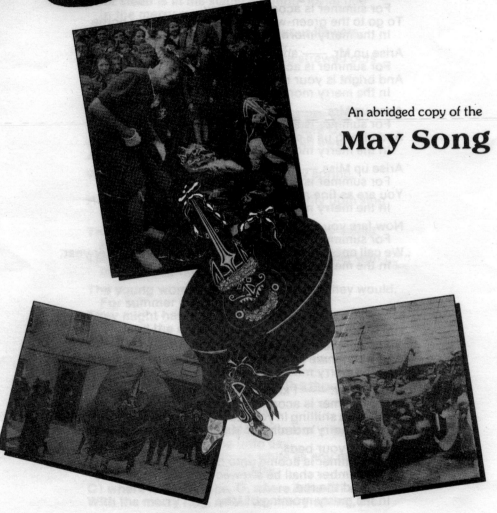

Included also is a Short Article
on the Possible Origin of this Ancient Custom

Padstow May Day Brochure, 2000

Clare Street, Cardiff, Wales, 2001

Clare Street Protest House, Cardiff

The occupier of this house in Clare Street, Cardiff got into a dispute with the City Council in 1984, and his house became a vehicle for his protest over the subsequent years.

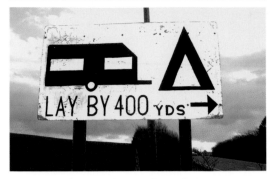

Camping Site Sign, near Padstow, Cornwall, 2000

Chestnuts Estate Agents,
Balls Pond Road, Islington, London, 2004

Lyndale Residential Park Sign,
Lytham St Anne's, Lancashire, 2005

Painted Shed, near Margate, Kent, 2003 (photo: Dan Bass)

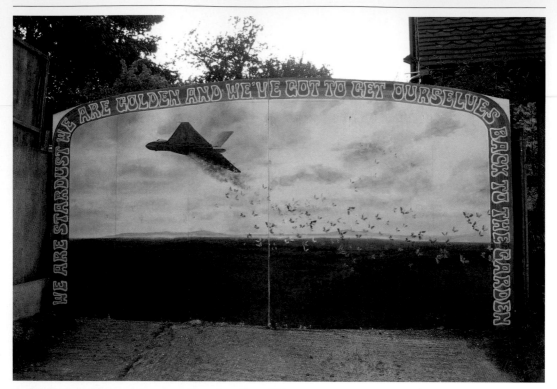

Garden Gate Anti-War Mural, Love Lane, Faversham, Kent, 2004

Crazy Golf House, Margate, Kent, 1999 (photo: Dan Bass)

Dish Cloth Houses by Olive Wagstaff,
Greenwich, London, 1999

Crib by Leo Kane, Stoke Newington, London, 2004

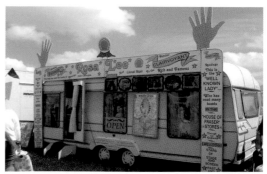

Rosa Lee's Caravan, Horse Fair, Appleby, Cumbria, 2002

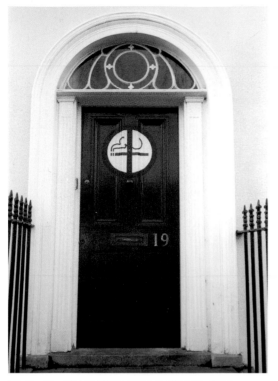

'No Smoking' Painted Door, Islington, London, 2004

Garden Design, Bermondsey, London, 2004

Decorated House Exterior, Clerkenwell, London, 2005

Garden Design, Chippenham, Wiltshire, 2005

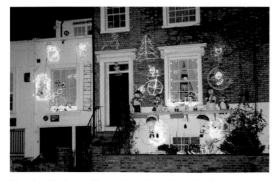

Exterior Christmas Decorations, Southgate Road,
Islington, London, 2004

Armchair Topiary, Port Isaac, Cornwall, 2004

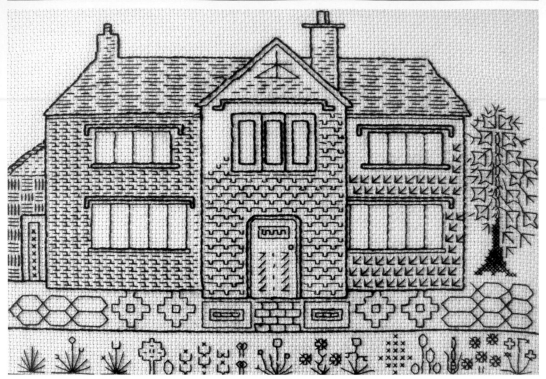

Blackwork Wall Hanging (detail), Salterforth Women's Institute, North Yorkshire, 2000

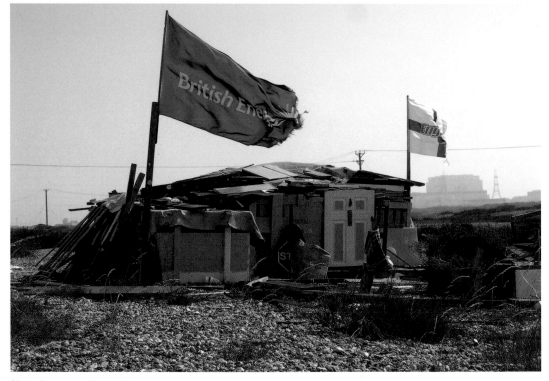

Shack, Dungeness, Kent, 2004

Made in Scotland, HMP Barlinnie, 2002 (HMP Leyhill Collection of Prison Art)

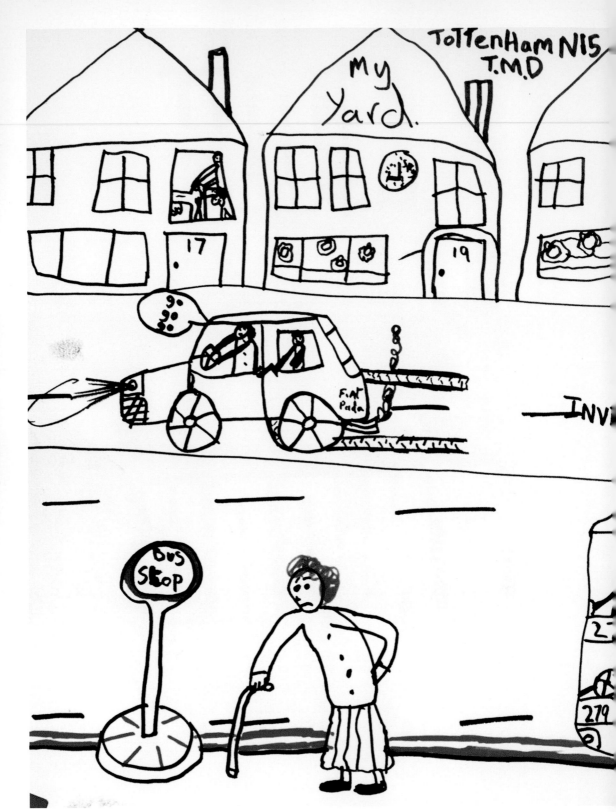

My Yard, Atkinson Young Offenders Unit, 2003 (HMP Leyhill Collection of Prison Art)

Graffiti, Leamington Spa, Warwickshire, 2000

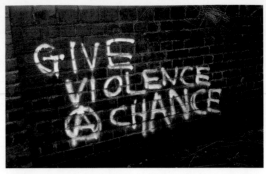

Graffiti, Leamington Spa, Warwickshire, 2000

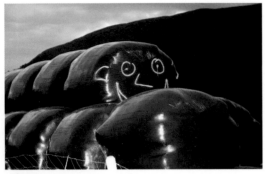

Graffiti on Hay Bales, near Skipton, Yorkshire, 2004

Graffiti, Islington/Hackney, London, 2003

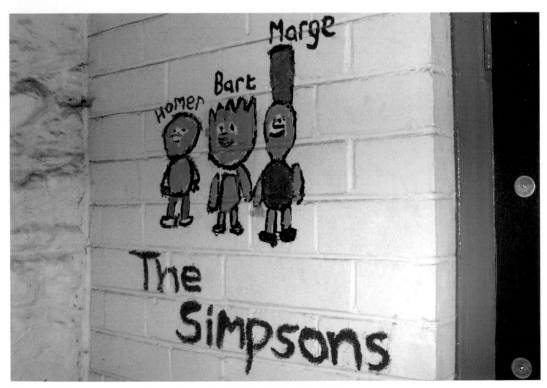

Simpsons Wall Painting, Burton Street Project, Sheffield, South Yorkshire, 2004

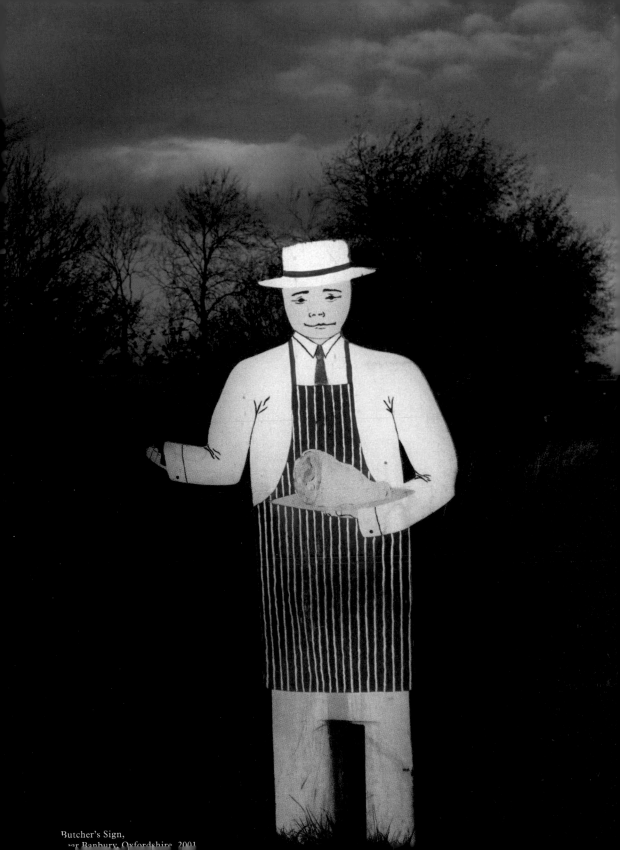

Butcher's Sign,
near Banbury, Oxfordshire, 2001

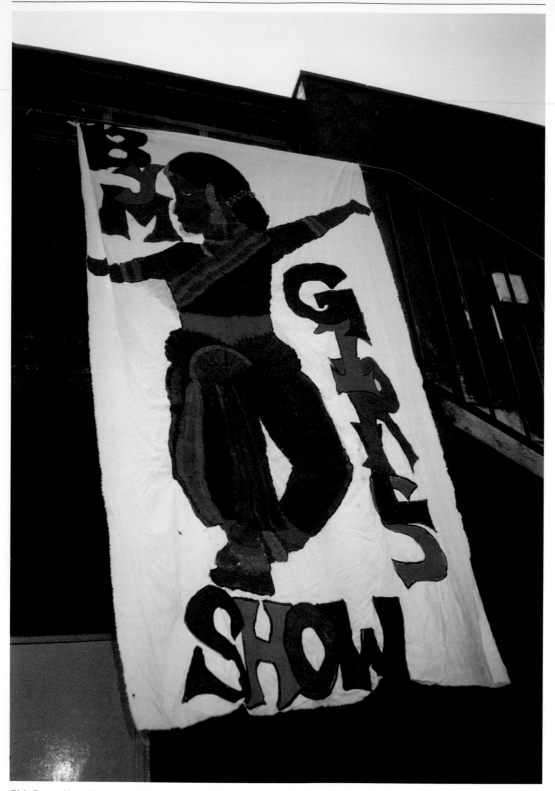

Girls Dance Show, Commercial Street, London, 2001

Hairdresser's Sign, Shoreditch, London, 2002

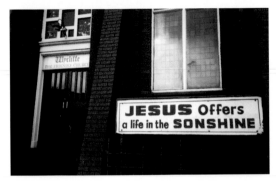

Jesus Advert, Preston, Lancashire, 2000

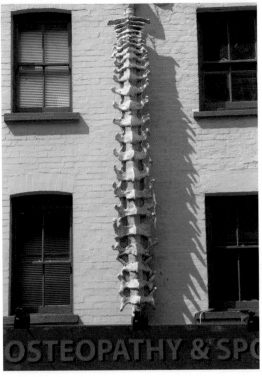

Osteopathy Sign, Shoreditch, London, 2004

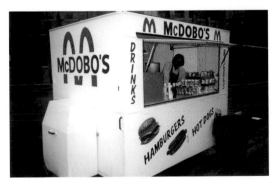

McDobo's Burger Stand, outside Tate Modern, London, 2000

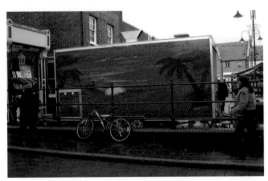

The Business Fast Food Wagon, Ely, Cambridgeshire, 2004

The Real Deal West Indian Restaurant Mural, Hackney, London, 2004

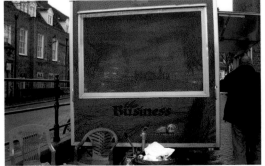

The Business Fast Food Wagon, Ely, Cambridgeshire, 2004

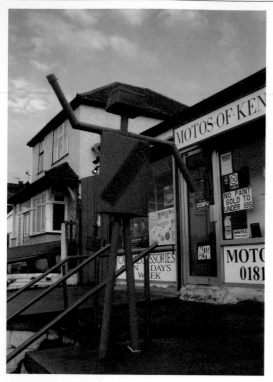

Shop Sign Figure, Motos of Kenley, Surrey, 2005

Traffic Sign Figure, North Cornwall, 2003

Commemorative Plaque, New North Road, Islington, London, 2005

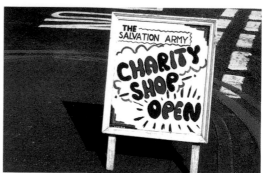

Charity Shop Sign, Margate, Kent, 2003 (photo: Dan Bass)

Shop Sign, Mac Services, Bodmin, Cornwall, 2003

Urban, HMP Manchester, 2004

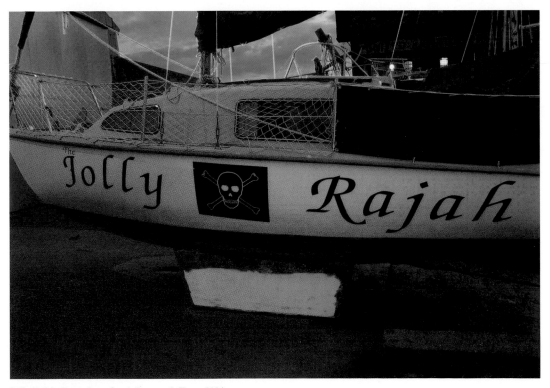

Jolly Rajah, Faversham Creek Boatyard, Kent, 2004

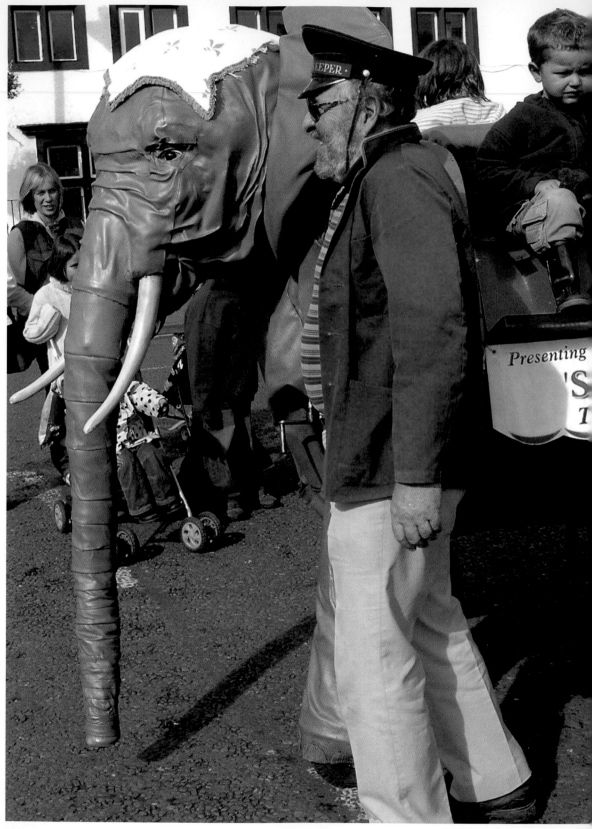

Folk Archive

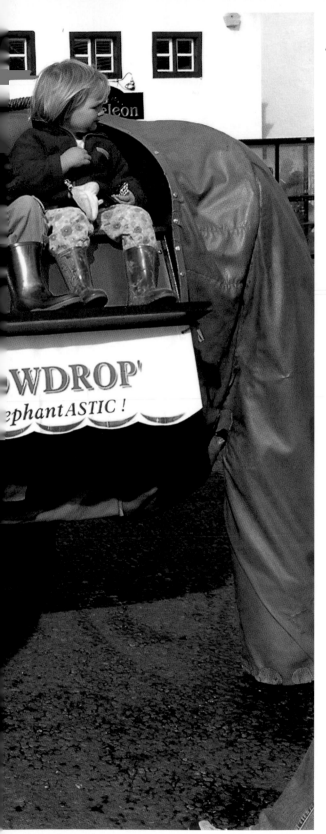

Snowdrop the Mechanical Elephant

'The idea had been with me for a long time but an incident in the centre of Bolton one Christmas really set the ball rolling. The whole town it seemed, including vast numbers of children, had gathered to witness the switching on of the lights by an elephant hired from a circus by the Council. They all waited but the animal did not arrive and the poor mayor had to break the bad news to the crowd. The incident convinced me that the days of exotic animal appearances in public were becoming a thing of the past. I suppose that it was about ten years before it could be described as finished. It was not my intention to parody the creature, but to nurture interest in automata as well as elephants. The public response to the contraption has been remarkable, particularly by children who display an entire spectrum of reactions to Snowdrop: excitement, delight, inquisitiveness and trepidation, even terror. The questions have been incredible.' — Peter Clare

Snowdrop the Mechanical Elephant by the Clare Family, Egremont, Cumbria, 2004

M1 Motorway Graffiti, 2004

Tot Rod, NASC Supernationals, Ipswich, Suffolk, 2004

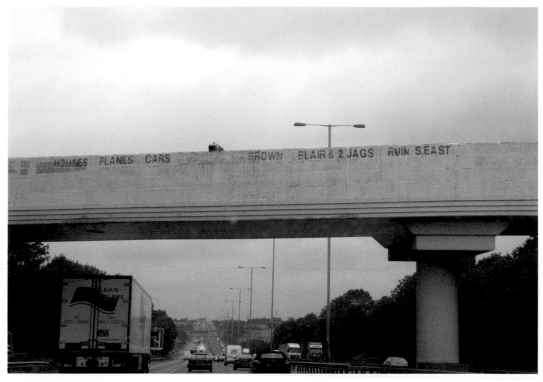

M1 Motorway Graffiti, 2004

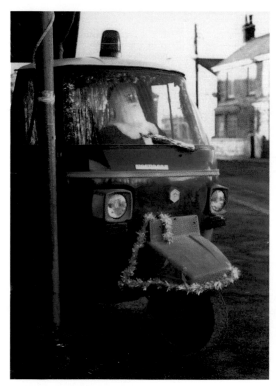

Father Christmas Van, St Austell, Cornwall, 2003
(photo: Elaine Udy)

Airbrush Bonnet, Brick Lane, London, 1999

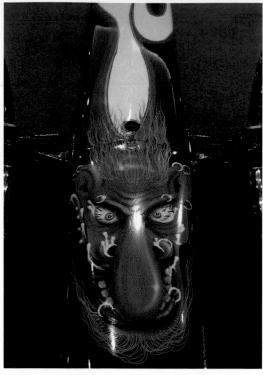

Homemade Motorcycle Fairing, Amhurst Road, Hackney, London, 2002

Painted Dragster Nose, Xtreme Wheels, London, 2005

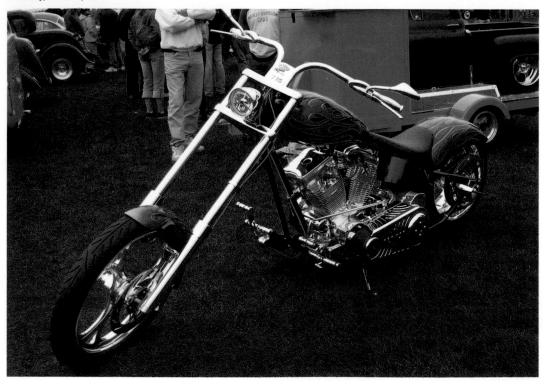

NASC Supernationals, Ipswich, 2004

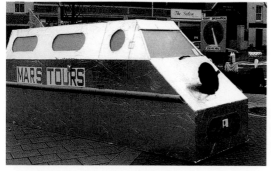

Mars Tours, April Fool's Joke, Birchington, Kent, 2003

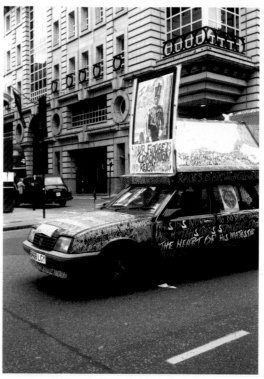

Trompe l'Oeil Painted Van, Charing Cross Road,
London, 2003

Painted Car Promoting Rastafarianism, Piccadilly,
London, 2002

NASC Supernationals, Ipswich, 2004

Smart Car by Alan Newman and Stuart Johnson

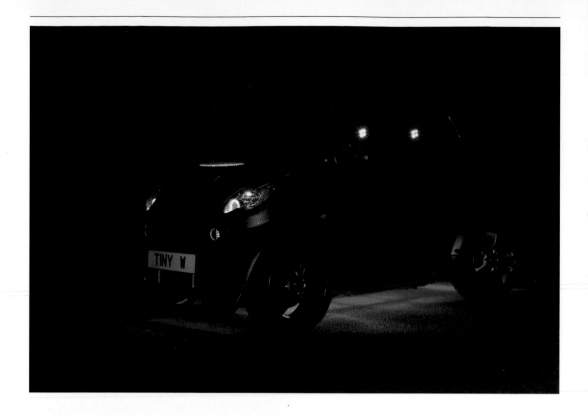

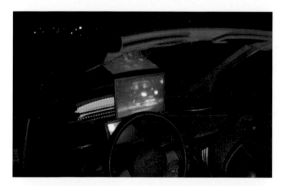

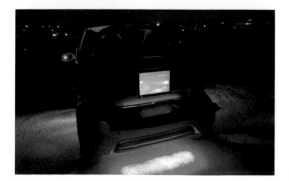

www.t1ny.com

Alan Newman and Stuart Johnson modify Smart Cars. Their website is formed by a group of friends who share the same passion for adapting their cars, opening them up, and spending incalculable amounts of time labouring over rebuilding the components of the car to their specifications (that include DVD players, flat-screen TVs, handcrafted neon fittings, and motion sensitive light switches). Their customised Smart Car is a work in progress: despite how detailed and customised the car gets, they like to keep the surface looking close to a factory standard.

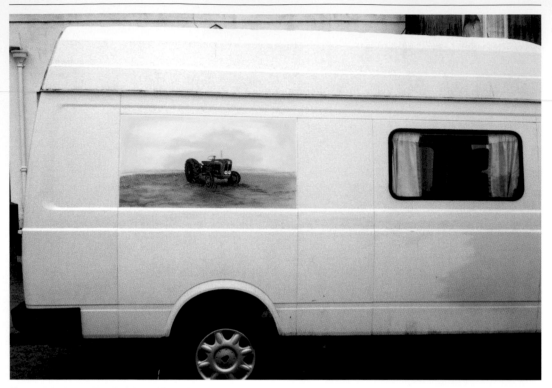

Tractor Painting on Van, Delabole, North Cornwall, 2002

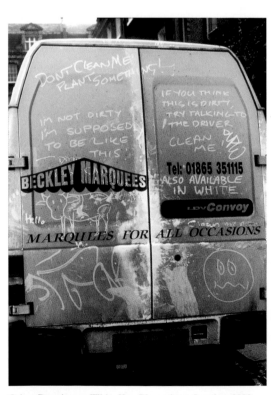

St John's Ambulance Pin Cushion by Rachel Williams,
North Yorkshire, 1999

Grime Drawing on White Van, Bloomsbury, London, 2003

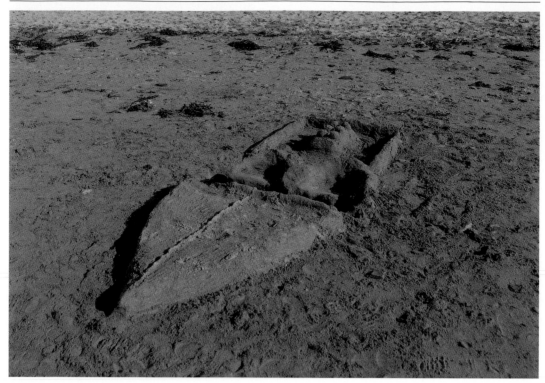

Speedboat Sandcastle, Daymar Bay, Cornwall, 2004

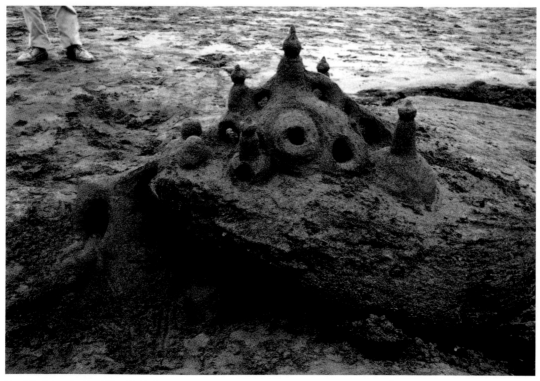

Sand Sculpture by N.R.Worrall, Trebarwith Strand, Cornwall, 2001

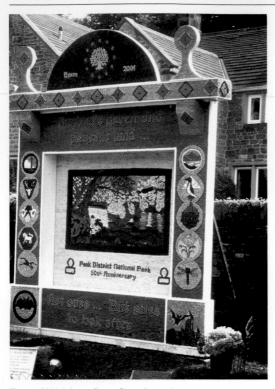

Eyton, 2001 (photo: Lynn Setterington)

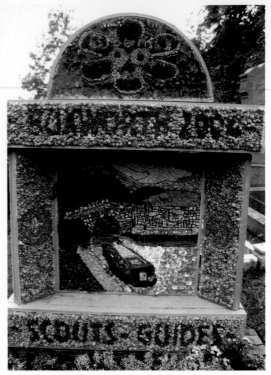

Buxworth, 2004 (photo: Lynn Setterington)

Well Dressing, Derbyshire

Well Dressing is a custom exclusive to Derbyshire, its origins are thought to derive from giving thanks for a fresh supply of water at a well or spring by adorning it with flowers. Today the dressings take the form of sophisticated mosaic pictures made out of petals and greenery. The subject matter is varied but there is a strong Christian element to the imagery. Up to a hundred wells are decorated throughout the summer months and they become a major tourist attraction.

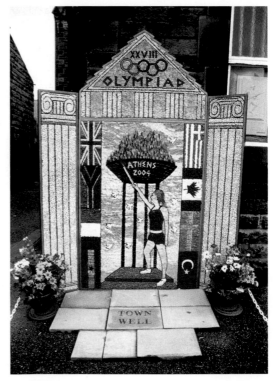

(photo: Lynn Setterington)

April Fool's Day Practical Joke, Birchington, Kent, 2001
(photo: Dan Bass)

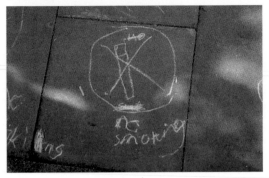

David Blaine Sculpture, St. Austell, Cornwall
(photo: Matthew Redman)

'No Smoking' Graffiti, Stoke Newington, London, 2004

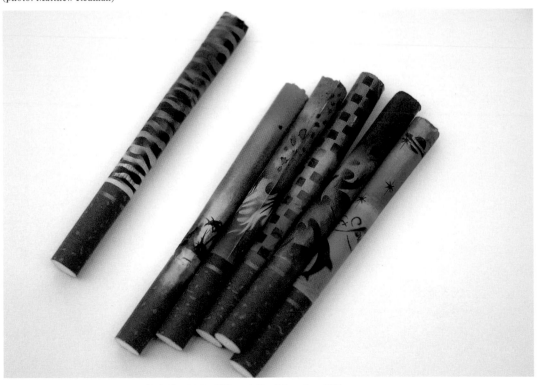

Customised Cigarettes by Tina at RichTina Nails, Walworth Road, London, 2000

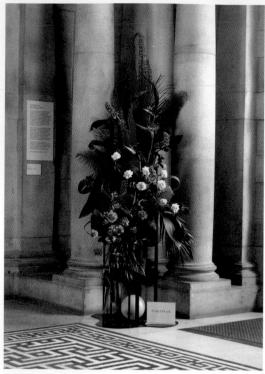

Carnival by Mrs Willatts
Women's Institute Flower Arrangements, Tate Britain, 2000

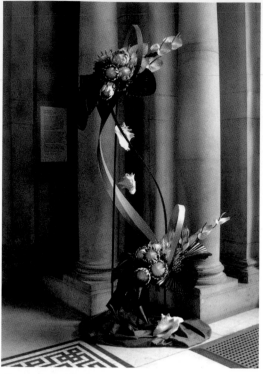

Abstract Composition by Mrs Bernard and her son Charles
Women's Institute Flower Arrangements, Tate Britain, 2000

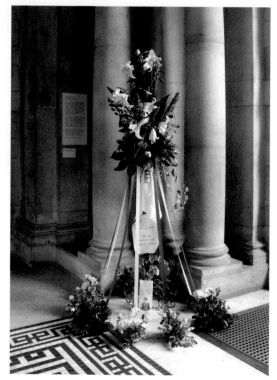

May Day by Mrs Fry
Women's Institute Flower Arrangements, Tate Britain, 2000

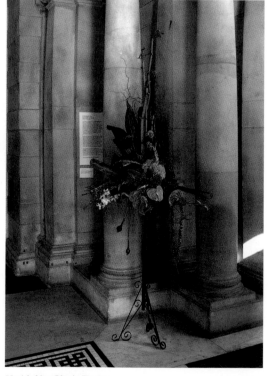

Untitled by Gloria Davies
Women's Institute Flower Arrangements, Tate Britain, 2000

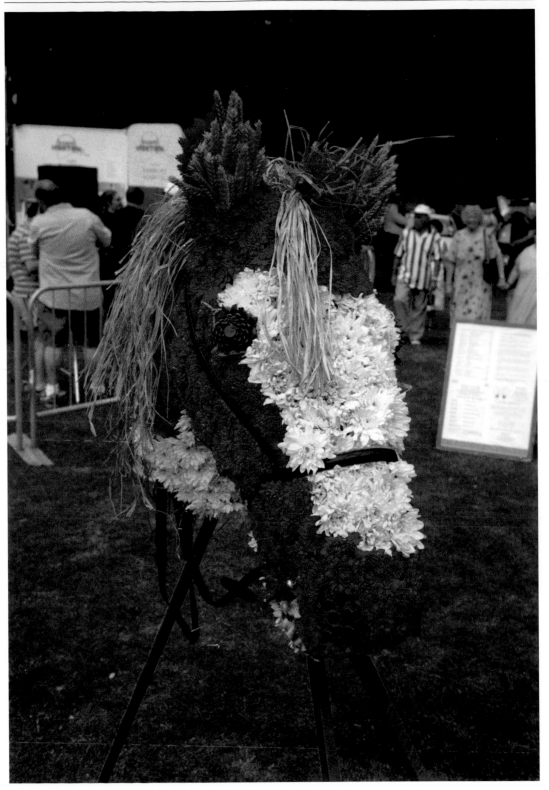

Flower Arrangement Horse's Head, Banbury, 2001

Crop Circles

Crop Circles began appearing in England in the late 1970s; the initial designs were based around simple circular patterns but recently they have become much more sophisticated. The early 1990s saw a massive interest in the phenomenon, and a competition was even held to make the best design. The most popular place to find these circles is in Wiltshire, especially close to the ancient monuments of Avebury and Silbury Hill.

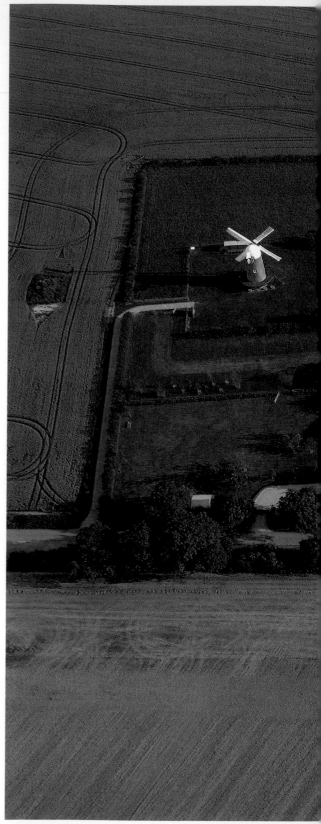

Crop Circle, Wilton Windmill, Wiltshire, 2004
(photo: Julian Gibsone) © www.cropcircleconnector.com

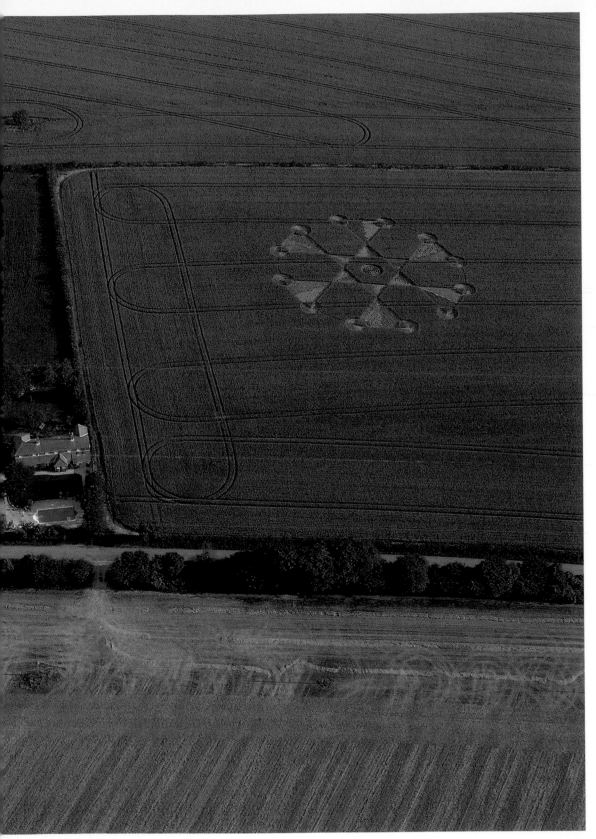

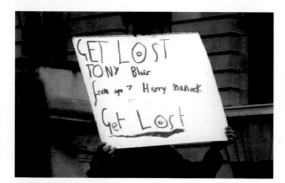
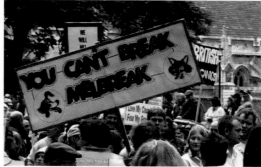
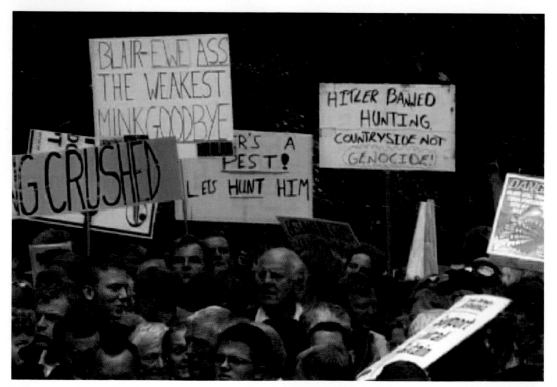

Banners at the Countryside Alliance Demonstration, London, September 2002

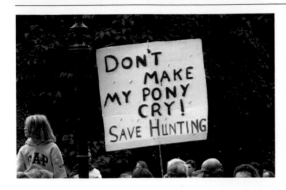

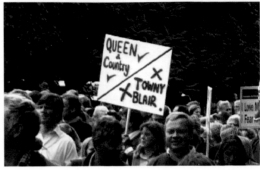

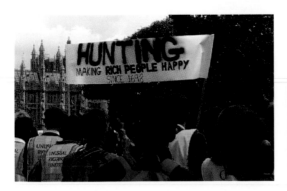

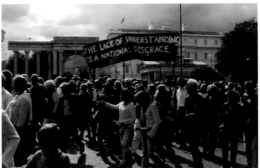

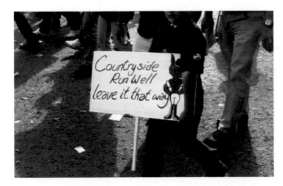

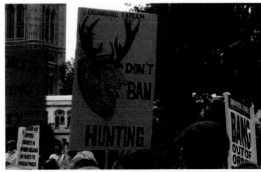

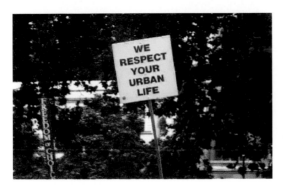

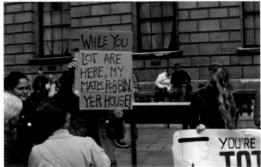

Counter-Countryside Alliance Demonstrators,
London, September 2002 (Bottom right)

Banners by Ed Hall

Ed Hall started making banners when he worked for Lambeth Council in the 1980s and since retiring he has devoted more time to their production. During the past twenty years he has made over four hundred banners for trade unions, activists and community groups as his contribution to the causes he sympathises with.

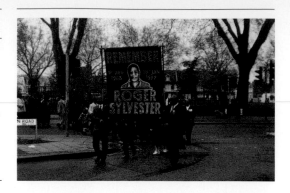

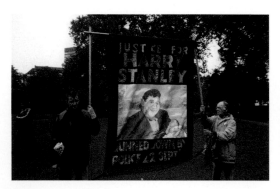

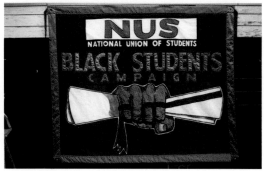

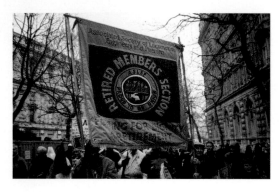

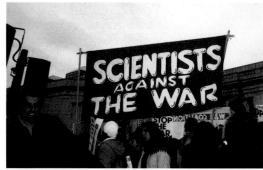

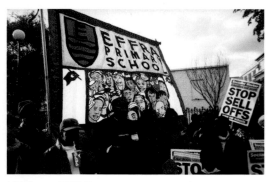

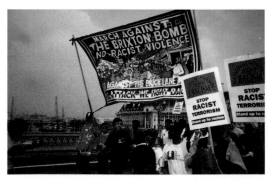

(All photos: Ed Hall)

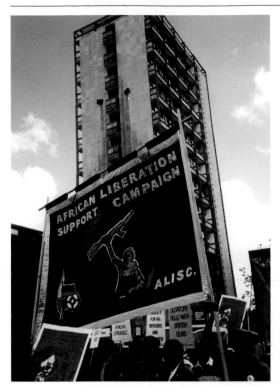

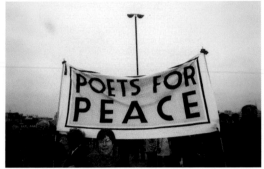

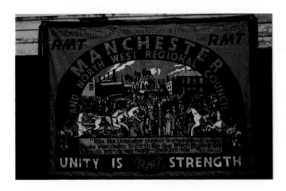

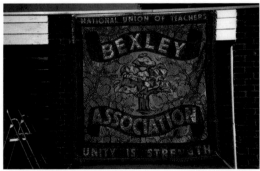

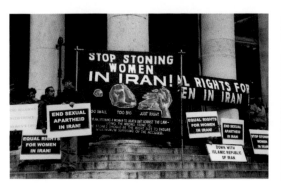

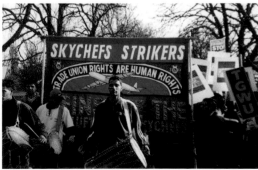

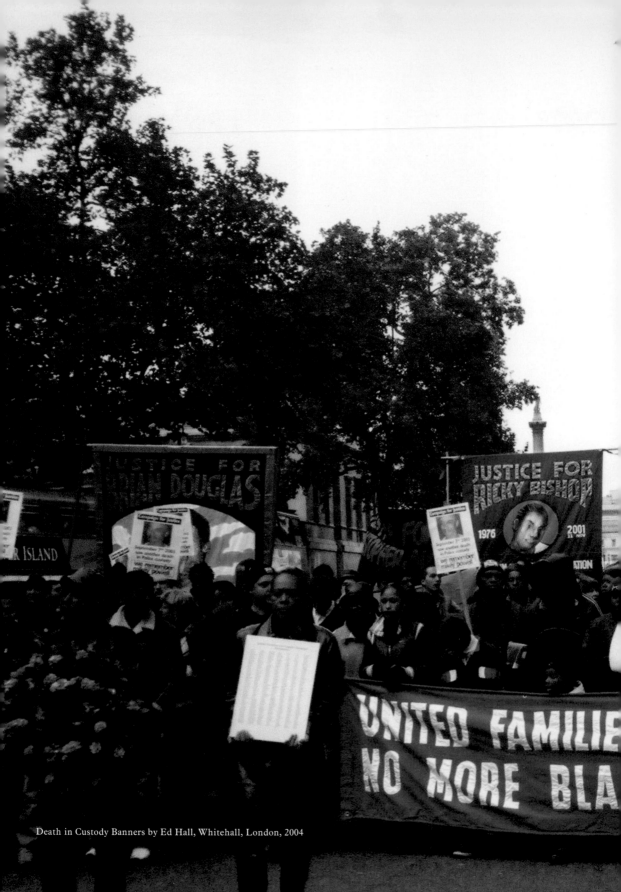

Death in Custody Banners by Ed Hall, Whitehall, London, 2004

JUSTICE FOR
JAMES GRAFTON

10ᵗʰ MAY 1975 — 25ᵗʰ NOV 1997
CHASED TO HIS DEATH
BY DROWNING IN THE RIVER
BY THE POLICE AND A PO

JUSTICE
FOR
DAVID
DAVIES

September 7ᵗʰ 2003
we remember
miledy powel

AGE
16
WHY?

AND FRIENDS CAMPAIGN
DEATHS IN CUSTODY !

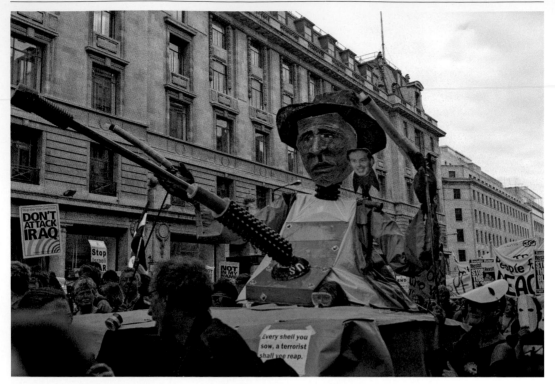

George Bush and Tony Blair Tank Sculpture, Stop the War March, London, 2002

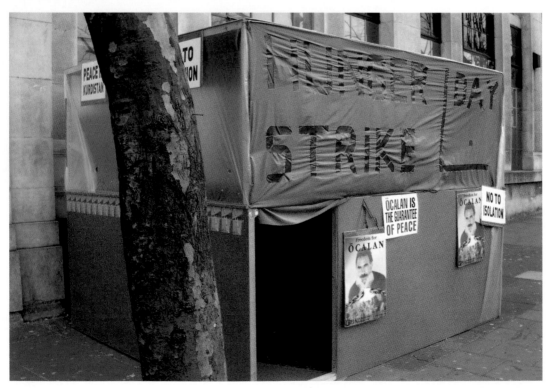

Hunger Strike Protest, Kingsland Road, Hackney, London, 2002

Folk Archive

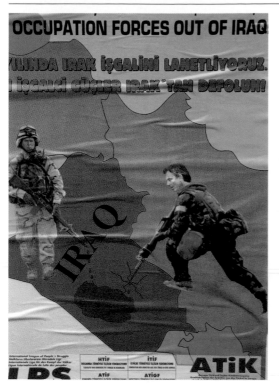

Anti-War Poster, Kingsland Road, Hackney, London, 2004

Tony Blair Scarecrow, Lancashire Wray, 2000

Anti-War Protester, London, 2002

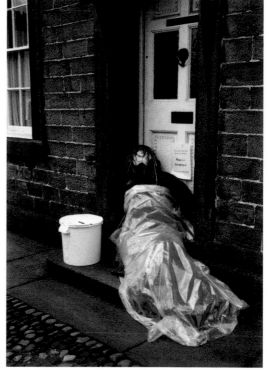

Homeless Scarecrow, Lancashire Wray, 2000

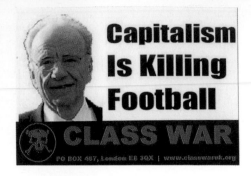

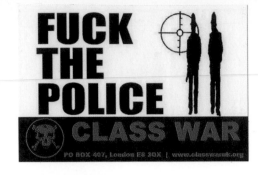

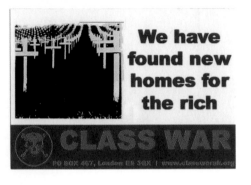

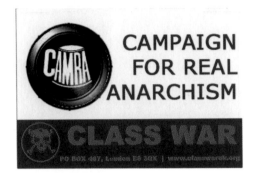

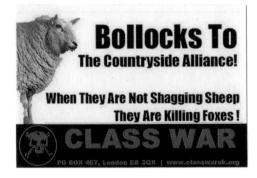

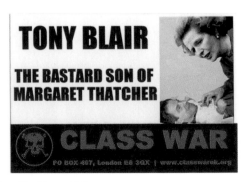

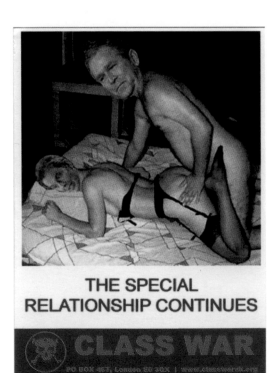

Class War Flyers, 2005

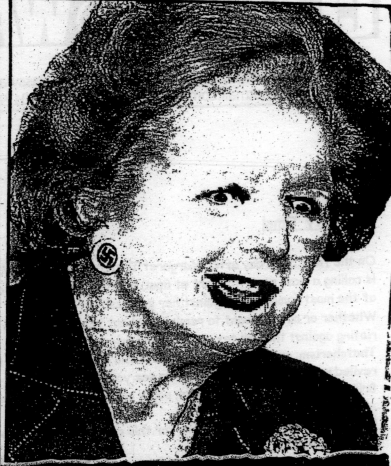

P.O. Box 467, London, E8 3QX.
www.londonclasswar.org
07931 301 901
classwaruk@hotmail.com

HURRY UP AND DIE

Party - The Saturday after she DIEs
6pm Trafalgar Square.... BRING Fireworks and Beer

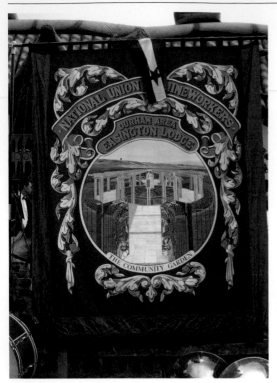

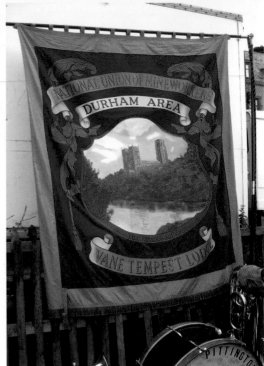

Durham Miners Gala

Durham Miners Gala is the largest Trade Union Rally in the country. Originally an exclusively National Union of Mineworkers event, it has since become a gathering of all sections from the UK Trade Union movement. The banners are paraded through the town to the sports field where there are speeches and music; in 2004 the banners were re-painted to commemorate the twentieth anniversary of the Miners' Strike.

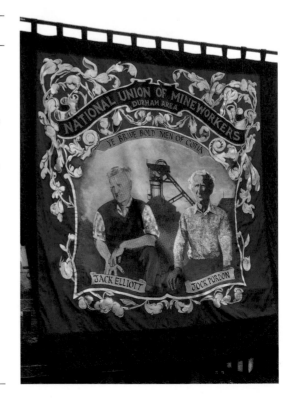

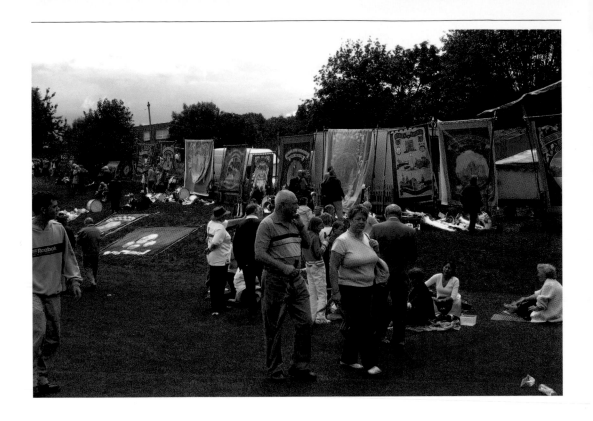

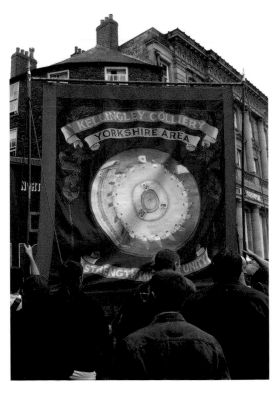

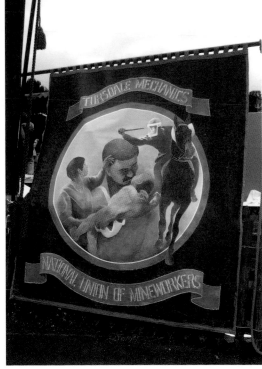

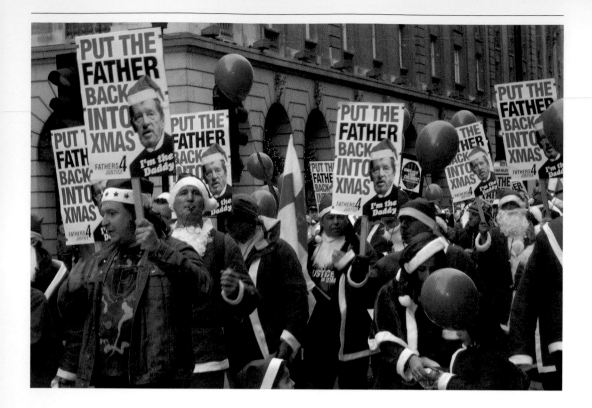

Fathers 4 Justice

The pressure group Fathers 4 Justice is an organisation that inventively combines humour and media savvy to communicate a serious message about their perceptions of the inequalities in family law. This march took place at Christmas 2004.

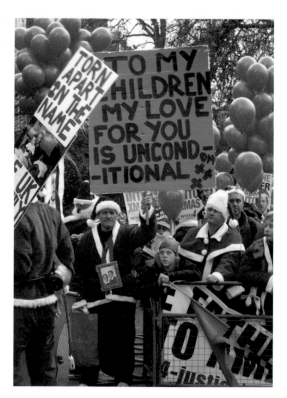

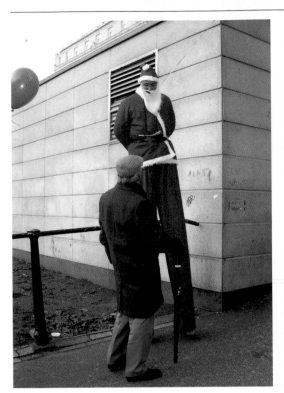

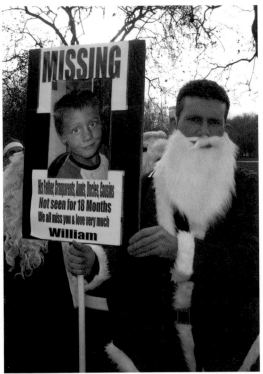

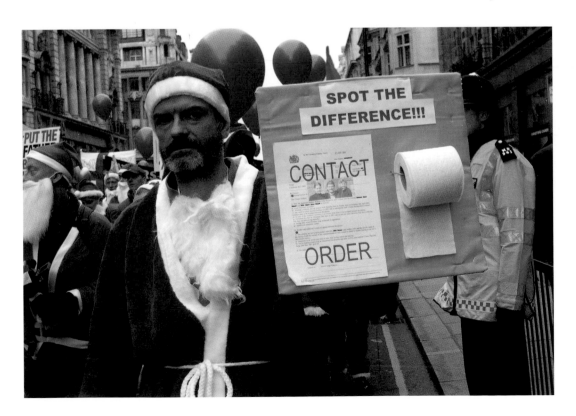

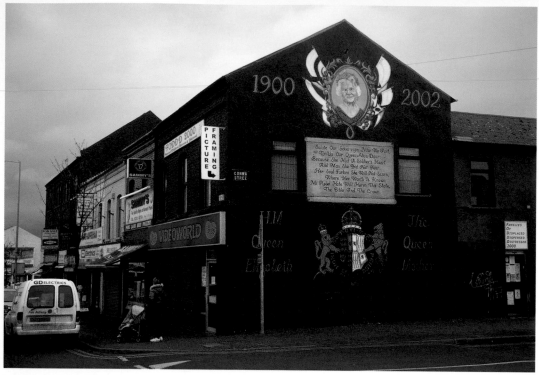

Loyalist Street Mural, Belfast, Northern Ireland, 2004 (photo: Ian Charlesworth)

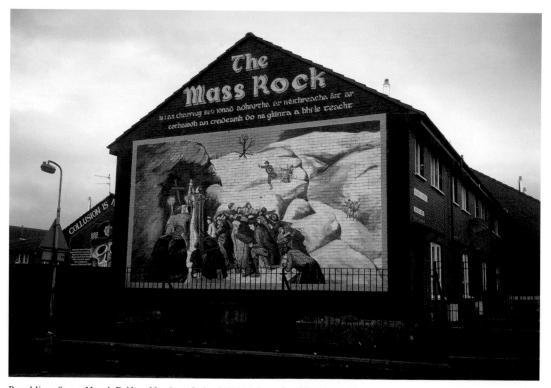

Republican Street Mural, Belfast, Northern Ireland, 2004 (photo: Ian Charlesworth)

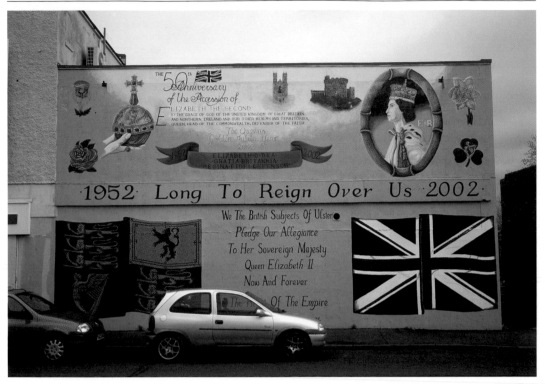

Loyalist Street Mural, Belfast, Northern Ireland, 2004 (photo: Ian Charlesworth)

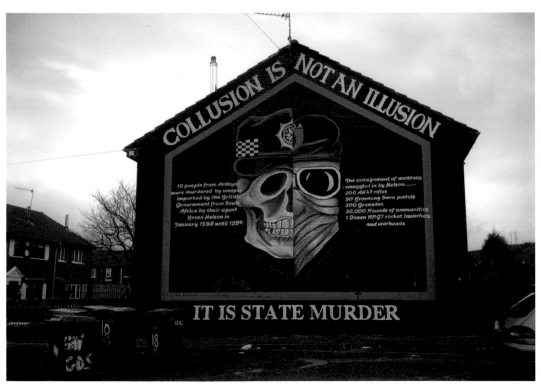

Republican Street Mural, Belfast, Northern Ireland, 2004 (photo: Ian Charlesworth)

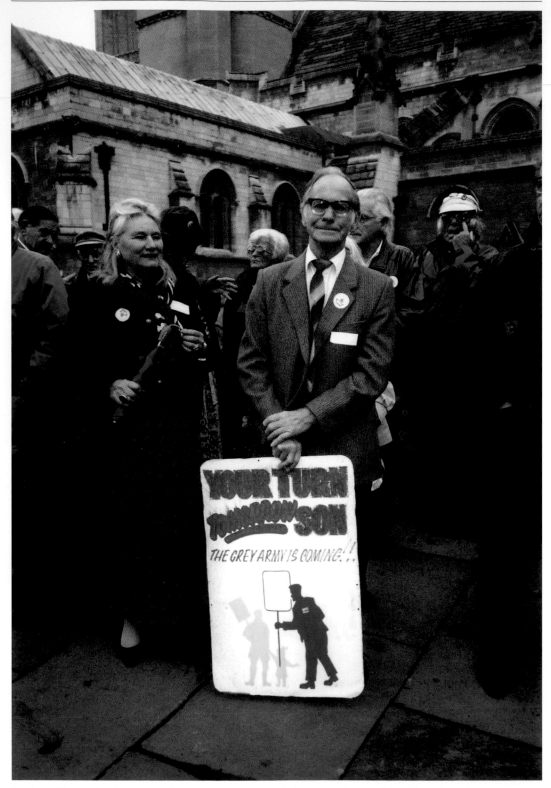

Pensioners' Protest, London, 2000. A few placards at this protest had obviously been made by a sign writer.

Anti-War Window Display, Silverback Records, Bloomsbury Way, London, 2003

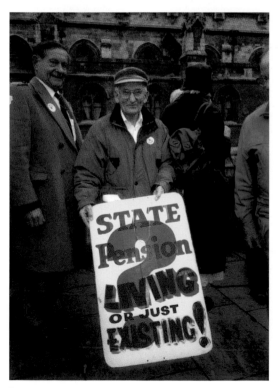

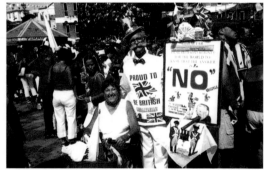

National Day, Gibraltar, 2004

Pensioners' Protest, London, 2000

Farmers' Protest, London, 2001

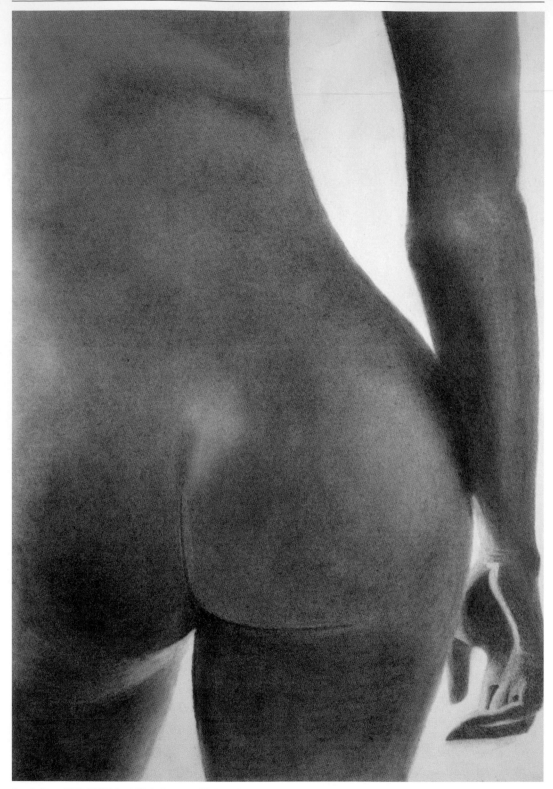

Lovely Bum, 2003 (HMP Leyhill Collection of Prison Art)

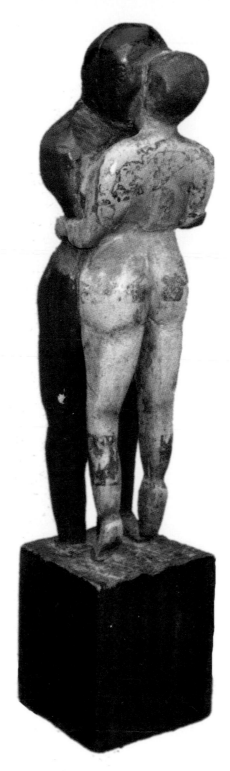

Carved Couple, Brixton, London, 1999

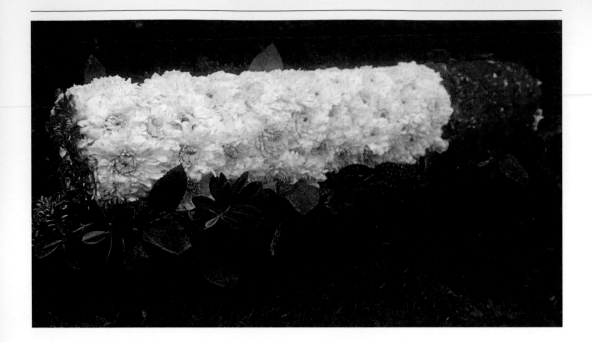

Cigarette Floral Tribute for Marie Ellis

'Marie Ellis died in 2005 aged 105 years and the
staff of the nursing home where she had been a
resident for years wanted a floral tribute made
that reflected her personality and put a smile on
people's faces, so I made a cigarette out of flowers.
Marie was a smoker up to her death so it seemed
more fitting than a cross. I've made a number
of other tributes including one in the shape of a
pint of Guinness and a map of Cyprus.'
— Niki Kallis, Margate, Kent, February 2005

Cigarette Floral Tribute for Marie Ellis, 2005
(courtesy Andy McCaren, Kent News and Pictures)

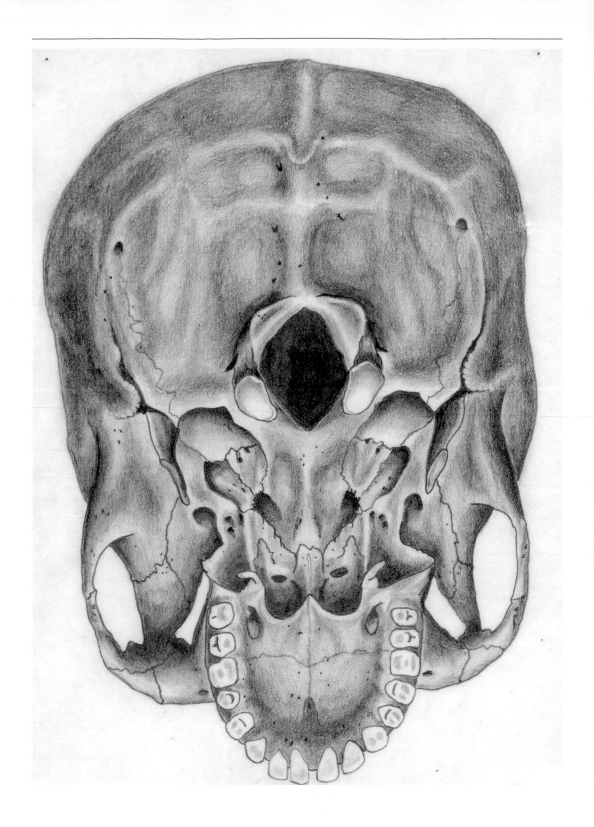

Skull Study, HMP Risley, 2003 (HMP Leyhill Collection of Prison Art)

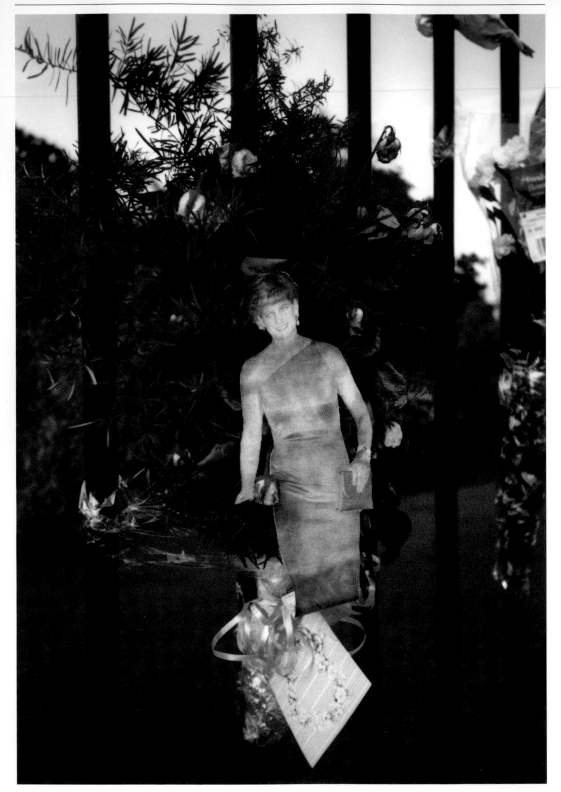

Princess Diana Anniversary Memorial Tribute, Kensington Palace, London, 1998

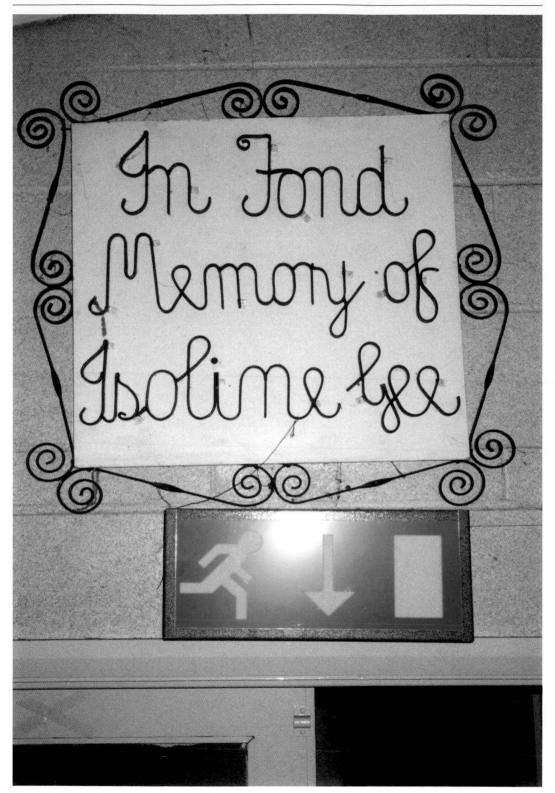

Memorial to Isoline Gee, Rowen, near Conwy, North Wales, 1999

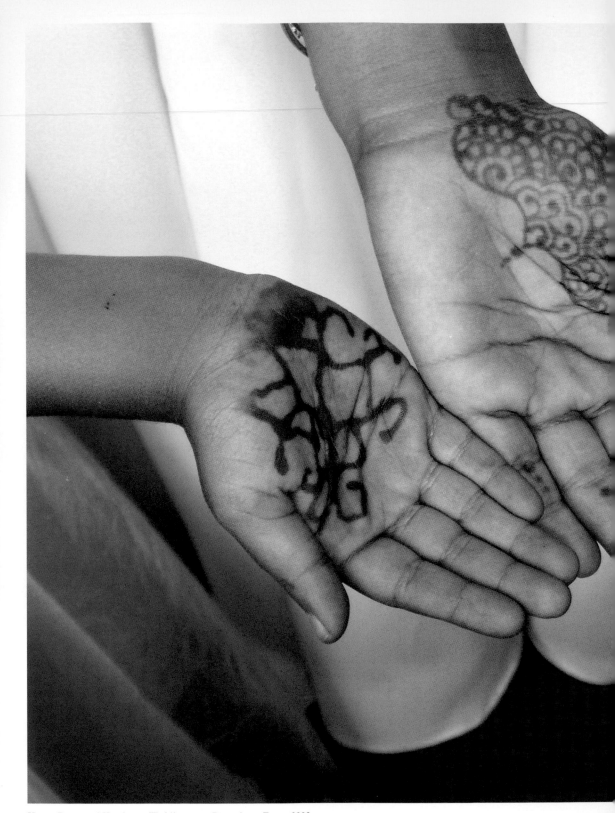

Henna Decorated Hands at a Wedding, near Dagenham, Essex, 2003

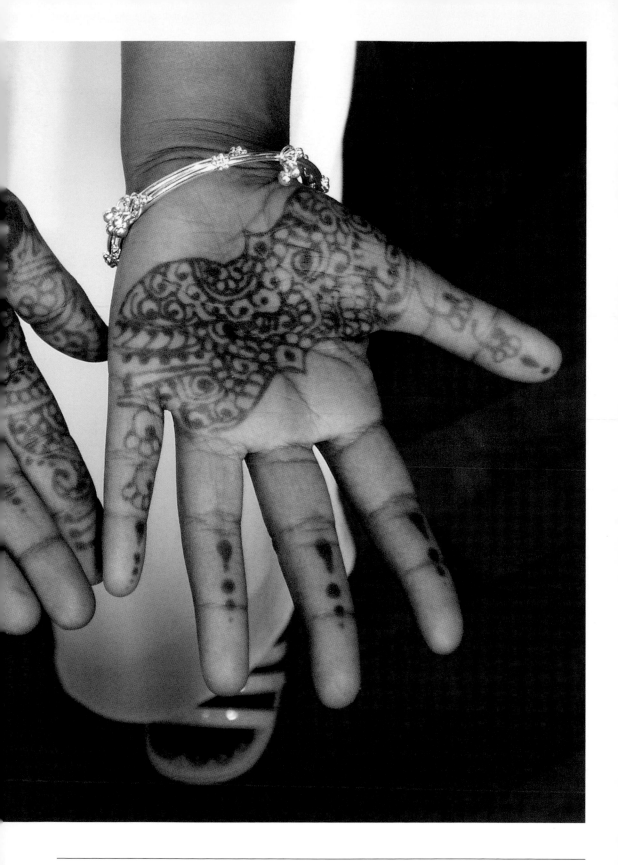

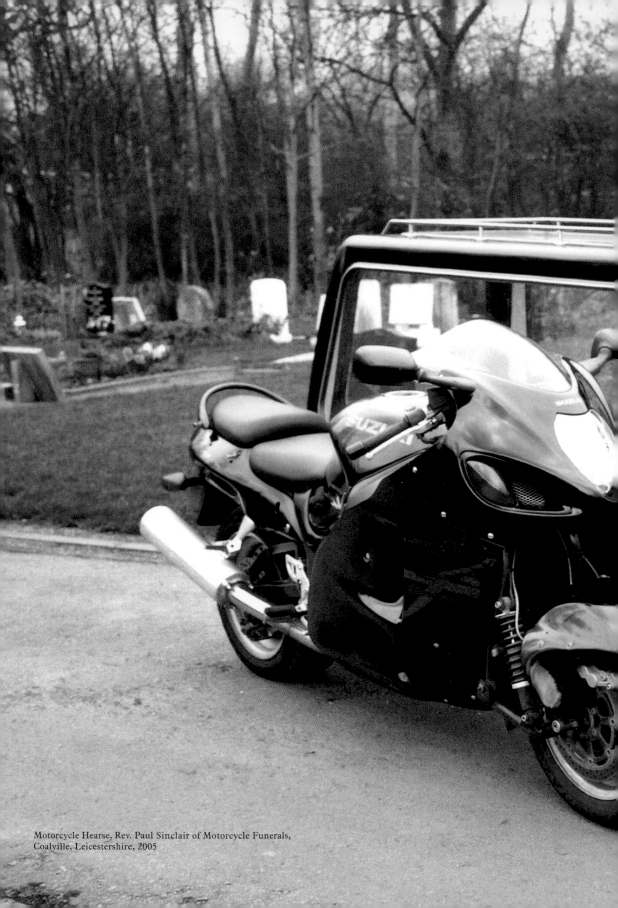

Motorcycle Hearse, Rev. Paul Sinclair of Motorcycle Funerals,
Coalville, Leicestershire, 2005

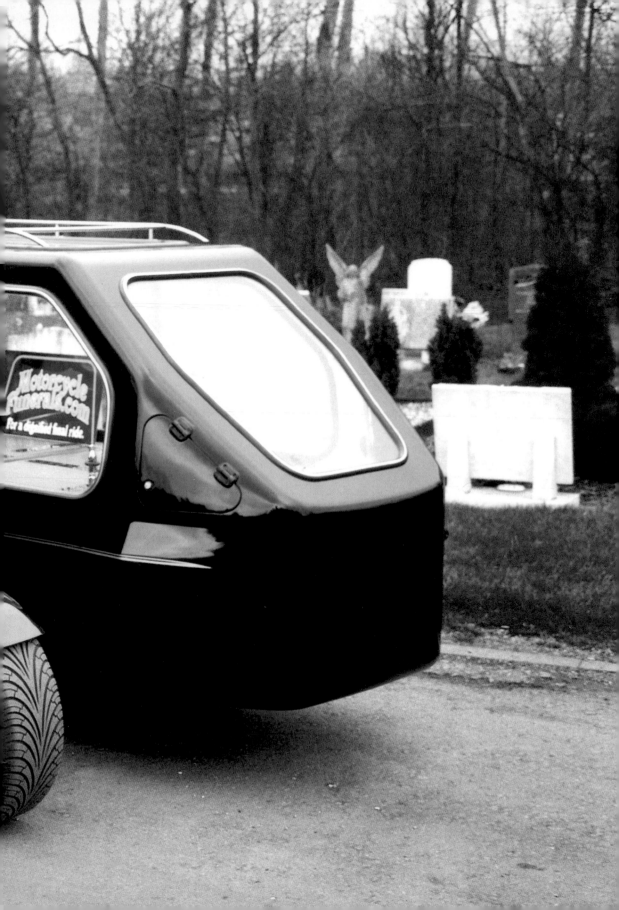

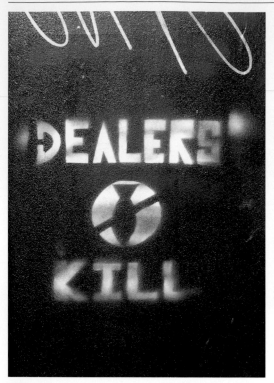

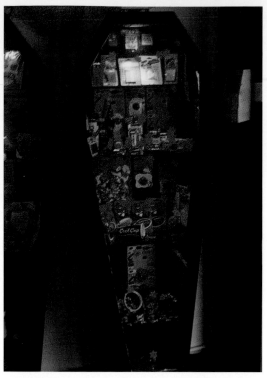

Dealers Kill Stencil, Kingsland Road, Hackney,
London, 2003

Joke Shop Coffin Display Cabinets, The Joke Shop,
Blackpool, 2005

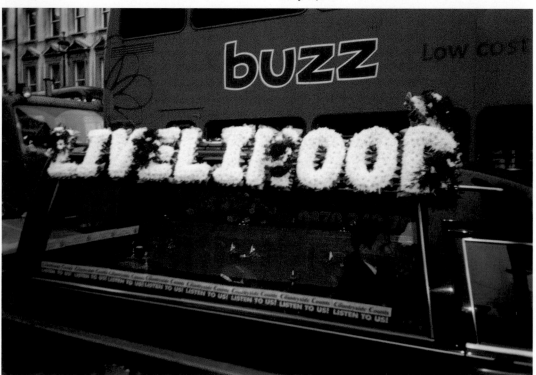

Liberty and Livelihood March, London, 2002

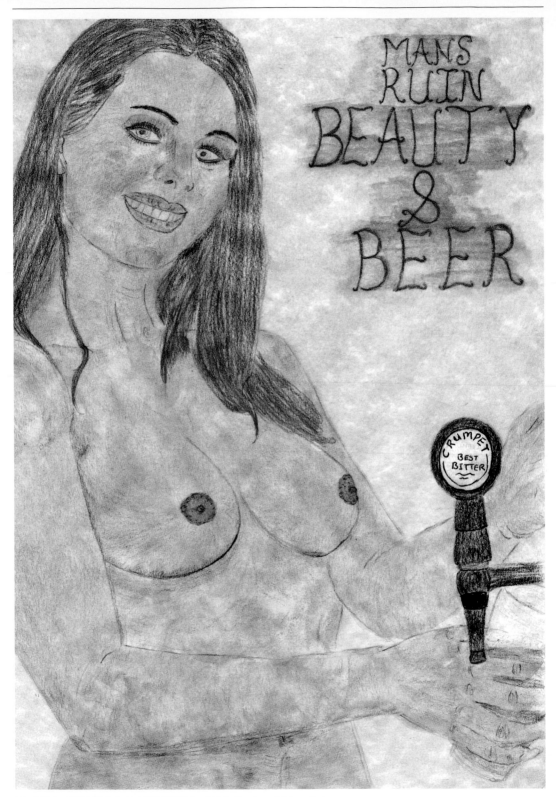

Man's Ruin, HMP Wakefield, 2003 (HMP Leyhill Collection of Prison Art)

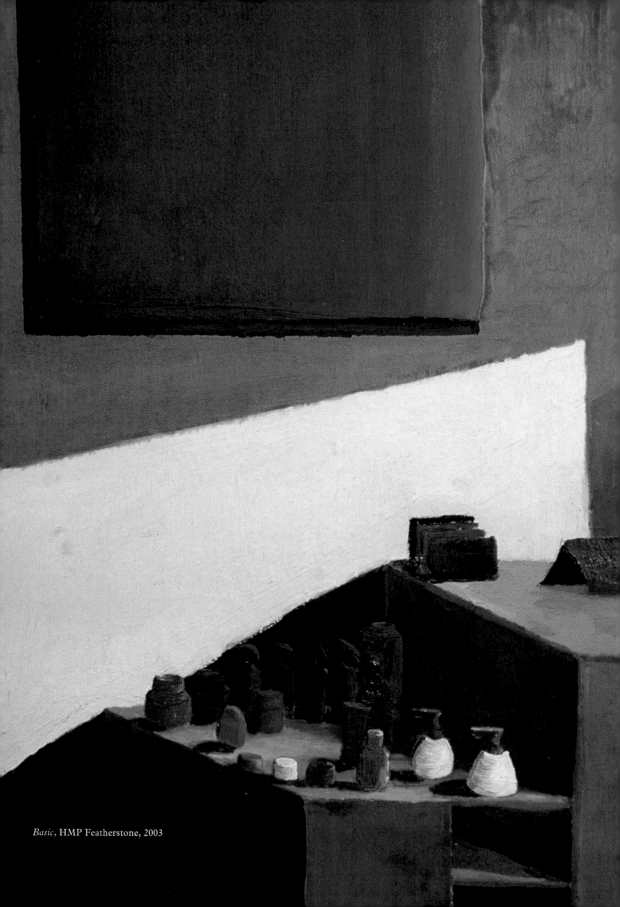

Basic, HMP Featherstone, 2003

Marked Men

'My dad used to hang about with the Krays. When he passed away I just thought I'd get the Krays' tattoo with my Dad on. I took in a picture of my dad and Sean just drew it. And he just copied a picture of the Krays onto my leg. My auntie, my dad's sister was a bit "Why did you get your dad on with the Krays?" I just said, "I love him and anytime I want to see him I just need to lift my leg up and have a look." and my son, who was born in 2000, when I ask him "Who's that?" He'll say, "That's the Krays." "And who's that?" and he'll say, "That's Grandad Minnie." '...

'I've got a few bits of work I still want to get done. My friend died there in June, Kegs, one of my best friends from Berwick. Died of cancer, thirty-four. There's a picture of him at a party last year and he's turning round with his mad grin. And I thought I'm going to get that tattooed on my leg, and I want to get it done before his anniversary. I think it's like a respect thing: how you respect someone. When it's done I'll be able to show his daughter. She's eleven. You get a buzz off of people asking to see your work. Total strangers have come up to us and said "Nice work you've got done there."' — Anthony

Extract from the book
Marked Men by Amanda Wait

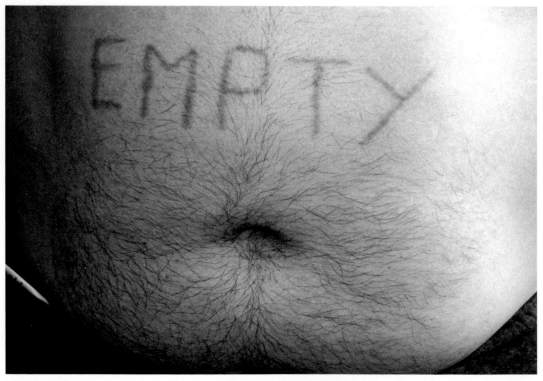

Empty Tattoo from the book *Marked Men* by Amanda Wait (photo: Amanda Wait)

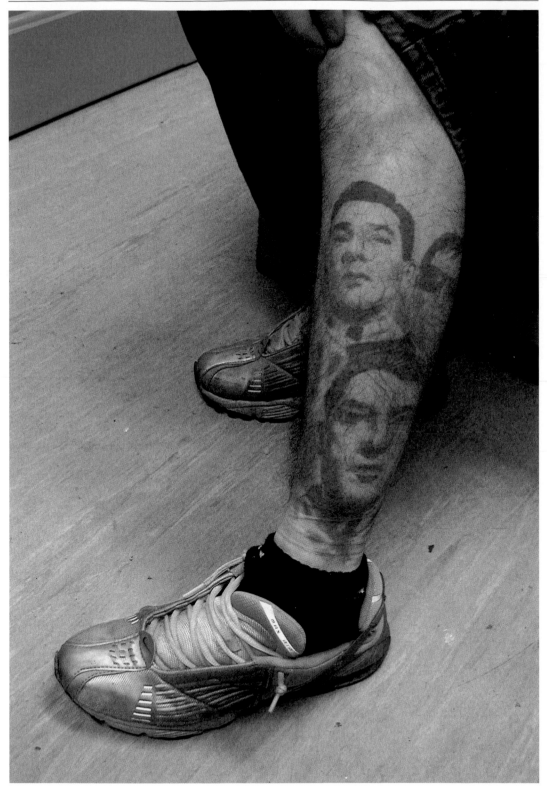

The Krays and My Dad Tattoo from the book *Marked Men* by Amanda Wait (photo: Amanda Wait)

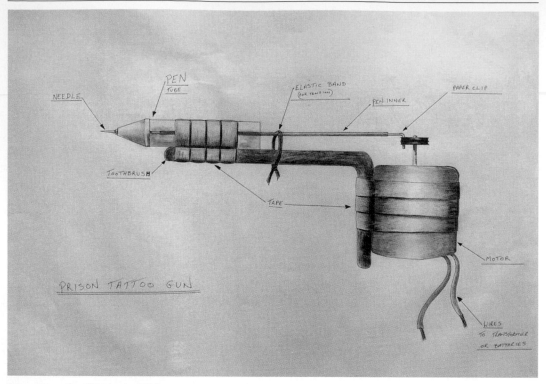

Prison Tattoo Gun Drawing by Bill Ross

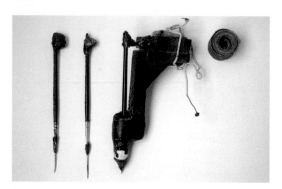

Confiscated Tattoo Gun from HMP Long Lartin
(courtesy Ellie Cooke)

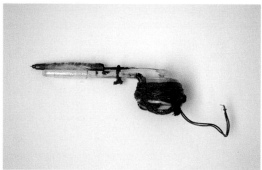

Confiscated Tattoo Gun from HMP Hull
(courtesy Ellie Cooke)

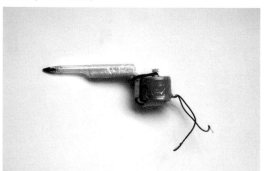

Confiscated Tattoo Gun from HMP Hull
(courtesy Ellie Cooke)

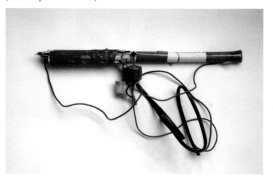

Confiscated Battery-Powered Tattoo Gun from HMP Leeds
(courtesy Ellie Cooke)

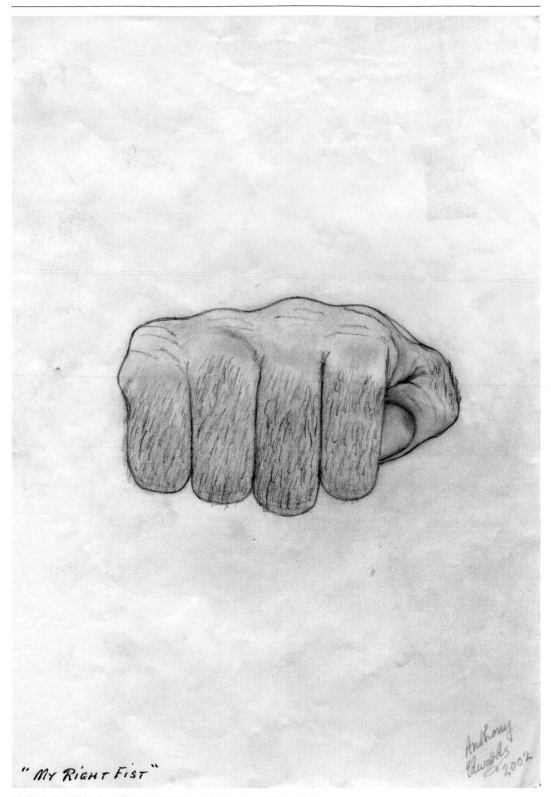

" MY RIGHT FIST "

My Right Fist, HMP Cardiff, 2002 (HMP Leyhill Collection of Prison Art)

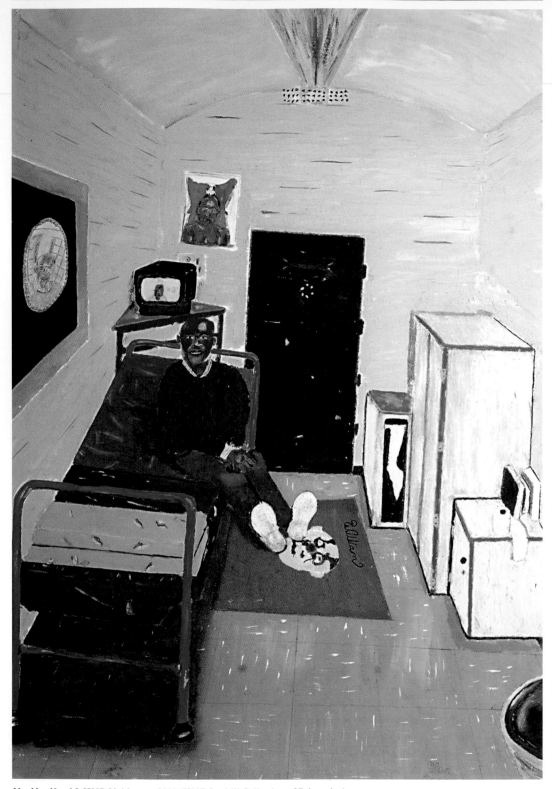

Me, Myself and I, HMP Maidstone, 2002 (HMP Leyhill Collection of Prison Art)

Welcome, C-type print, HMP Kingston, 2003 (HMP Leyhill Collection of Prison Art)

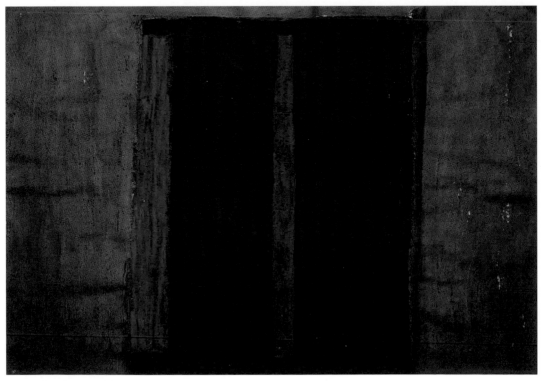

Red Window, Rampton Hospital, 2003

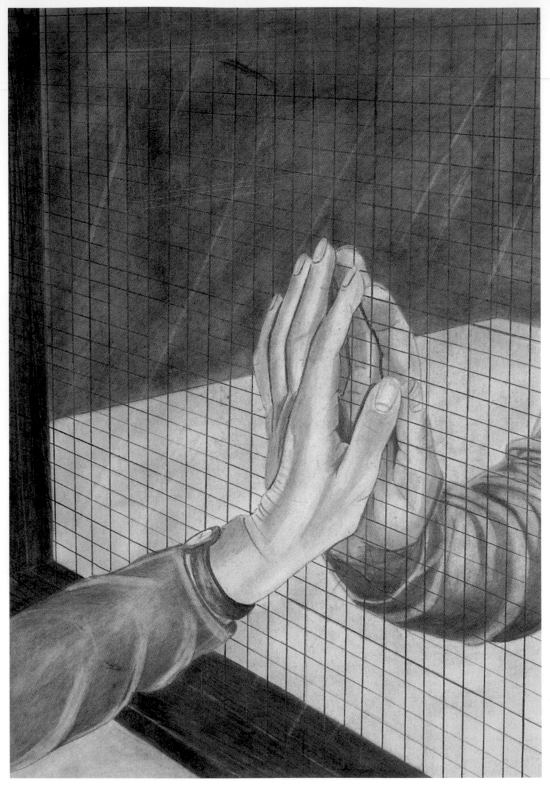

Closed Visit (detail), HMP Grendon, 2003 (HMP Leyhill Collection of Prison Art)

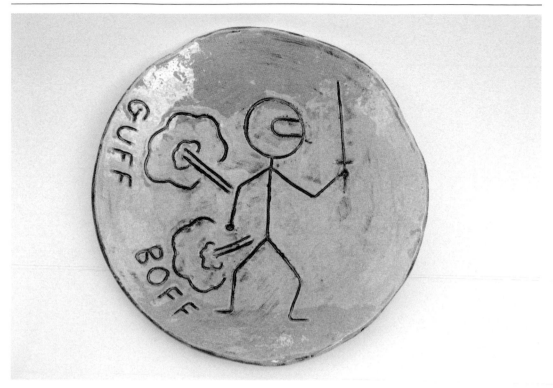

Guff Boff Bowl, Ashworth Hospital, 2003

Art from Prisons

Many of the preceding works of art from prisons were acquired through the Koestler Awards Scheme: a charitable foundation aimed at promoting and rewarding creative endeavours from men and women held in prisons, young offenders institutions and special hospitals in the UK. There is an annual exhibition and sale of works and prizes are given in a variety of categories that cover music, writing and the visual arts.

THE RAMPTON TAP

Drip-Drop, Drip-Drop **WILL IT EVER STOP?????**

The Rampton Tap, Rampton Hospital, 2003

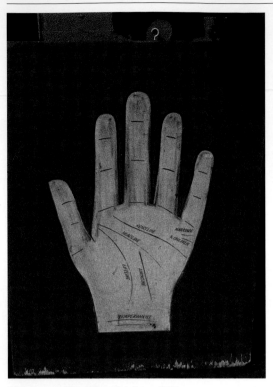

Clairvoyant's Hand Sign, Brighton, 2002

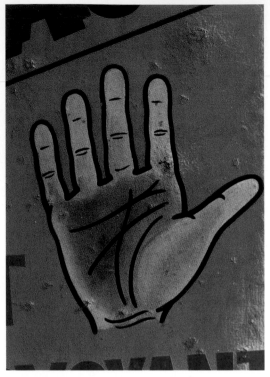

Clairvoyant's Hand Sign, Brighton, 2002

Clairvoyant's Hand Sign, Blackpool, 2005

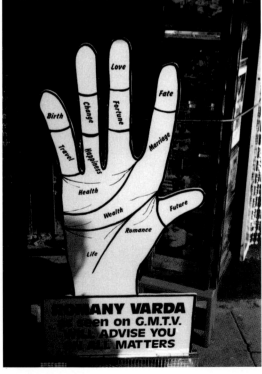

Clairvoyant's Hand Sign, Blackpool, 2002

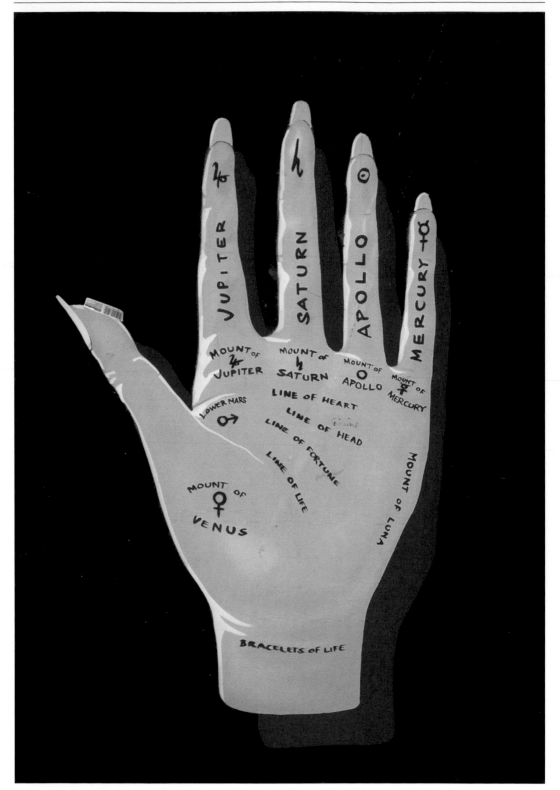

Clairvoyant's Hand Sign, Blackpool, 2005

Blessing of the Seas, Margate

Blessing of the Seas takes place in early January. The Greek Orthodox Church organises this ceremony, attended by mayors from across the Kent coastal region, the Bishop of the Greek Orthodox Church and other dignitaries. The party assembles on Margate Sands where a service is conducted on the beach, the climax of which is a cross that is thrown into the sea, which a boy is then sent to retrieve.

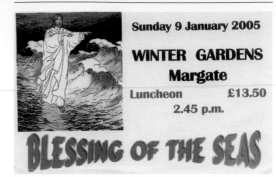

Sunday 9 January 2005

WINTER GARDENS Margate

Luncheon £13.50
2.45 p.m.

BLESSING OF THE SEAS

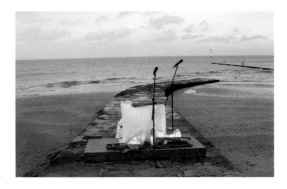

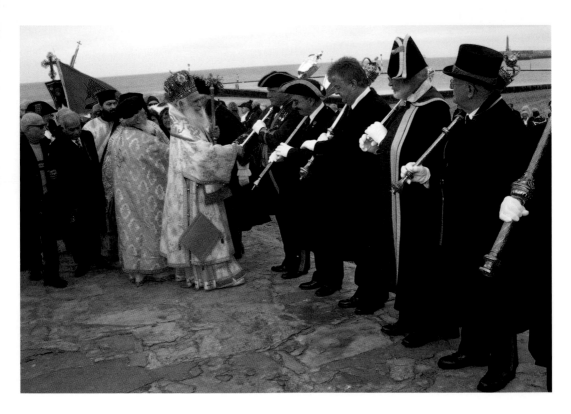

Rock Head by Andy Kania, Rock Candy Kingdom,
Blackpool, 2000

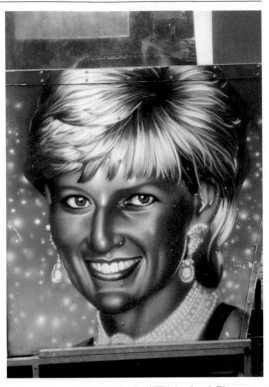

Diana Fairground Painting by Paul Wright, South Pier,
Blackpool, 2005

Joke Shop Display, Blackpool, 2005

Rock and Ices Sign, Hastings Pier, 2005

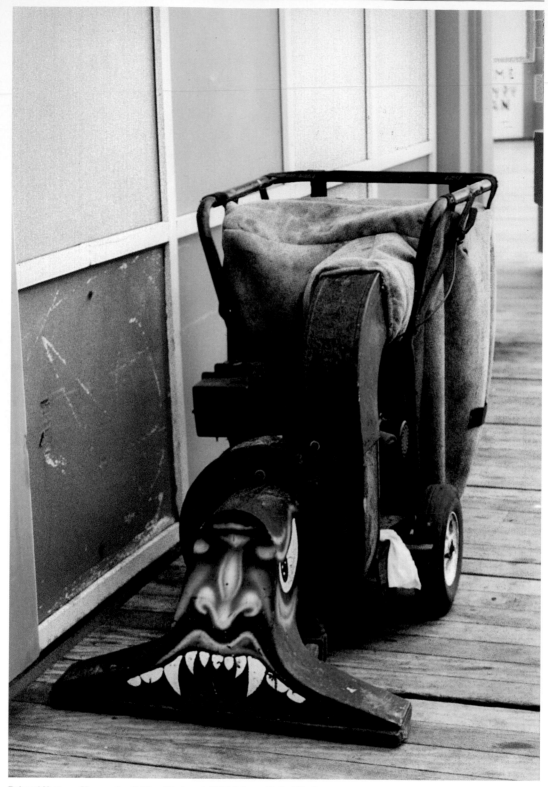

Painted Vacuum Cleaner, South Pier, Blackpool, 2003 (photo: Cathy Ward)

Thunderbirds Truck Cab, Margate, 2004 (photo: Dan Bass) Keith Richards Truck Cab, M2 Motorway, Kent, 2003

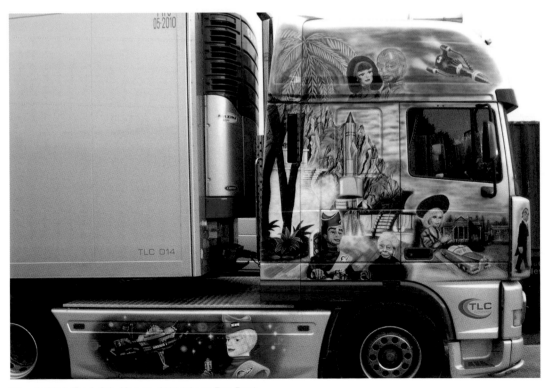

Thunderbirds Truck Cab, Margate, 2004 (photo: Dan Bass)

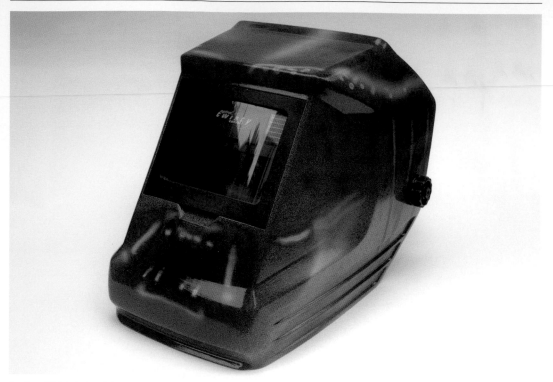

Predator Welder's Mask by Dave Crossley, Preston, 2000

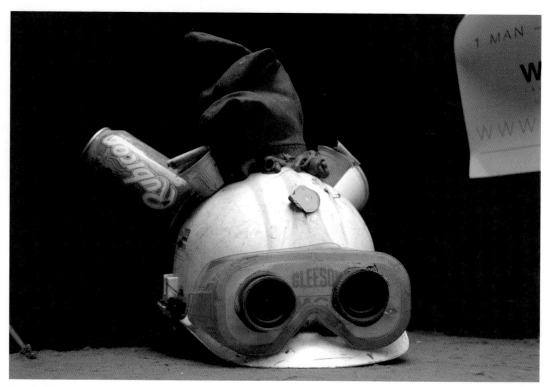

Modified Hard Hat by Terry of Costain Taylor Woodrow, Milk Dock Site, King's Cross, London, 2004

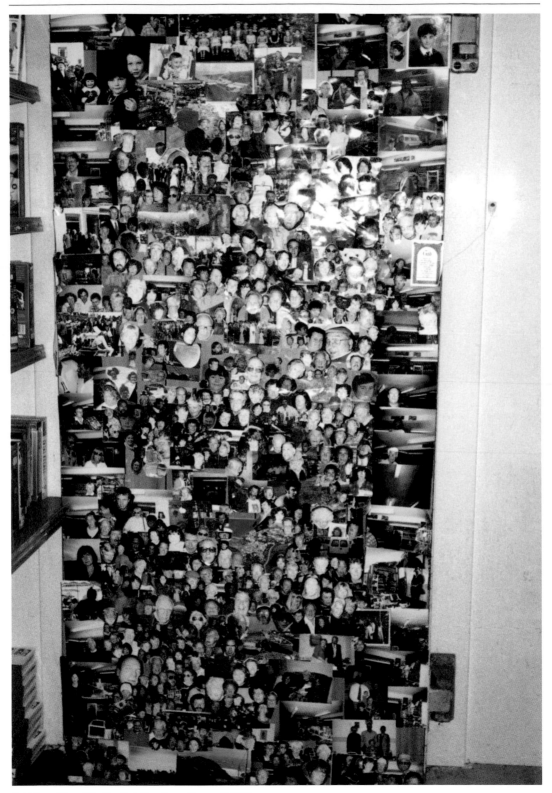

Cold Store Door, The Pea Pod, Port Isaac, Cornwall, 2000

Sick Notes Envelopes

'The sick notes that are handed into the Jobcentre Plus in St Austell for people on the sick are collected by the customer-facing staff at the front desk throughout the day. These items are set aside until late afternoon when they are sent via courier 'up the road' to the SSO building where the Incapacity Benefit Department can process them. The brown envelopes are used to keep them all together and prevent them getting lost. Dean Biggs, a security guard, draws a different design each day on the sick note envelope.'
— Matthew Redman, St Austell, Cornwall, 2005

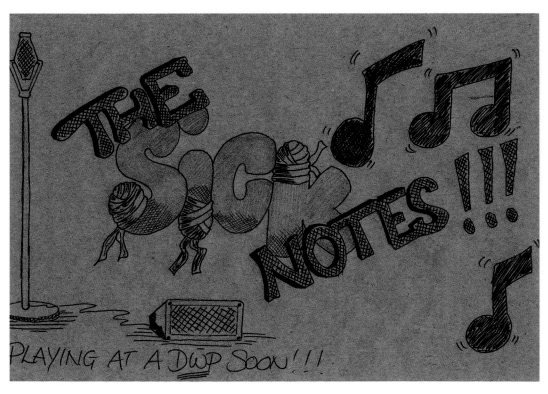

Louise

Caning!

Call: **7813 0437**

Warren Street
Hotel Visits Available
Realistic Prices

ACHING BUTTOCKS

Sensual Spanking
C.P. and Intimate
Exposure

734 8513
Local

Young & Foolish

All Fantasies Welcome
All Services
No Rush
Very Friendly

8374 4530

Mayfair Area

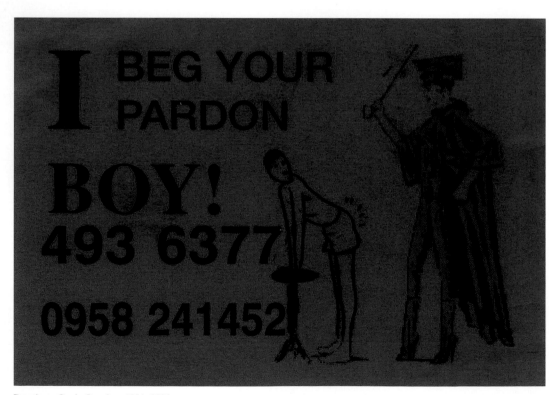

I BEG YOUR
PARDON

BOY!
493 6377
0958 241452

Prostitute Cards, London, 1994–2005

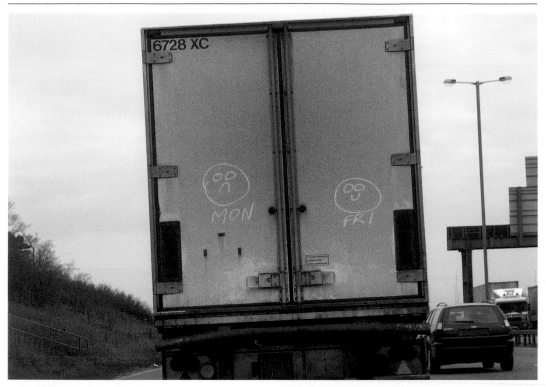

Back of Lorry, M1 Motorway, 2004

Decorated Asphalter's Truck, Brighton, 2002

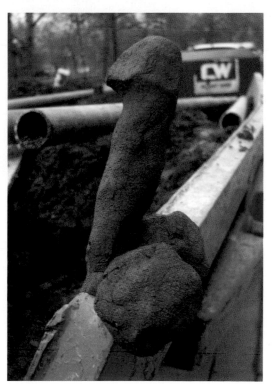

Builder's Sculpture, Islington, London, 2005

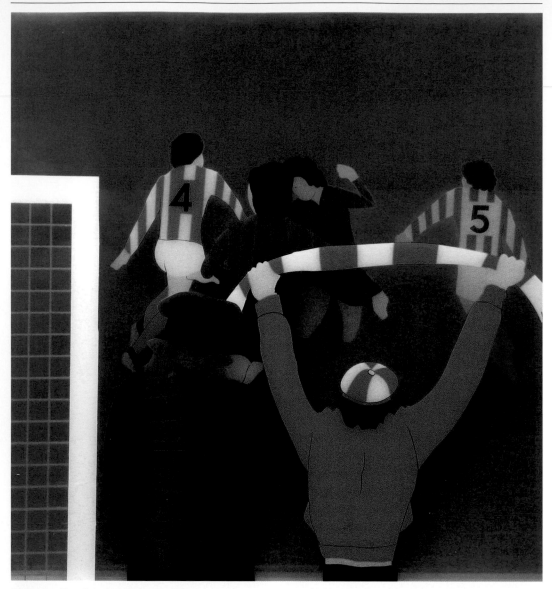

3D Betting Shop Painting, Glasgow, c.1996

Betting Shop, Doncaster, 2004

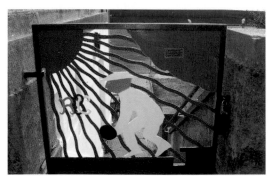

Bowling Club Gate, Ramsgate, 2004

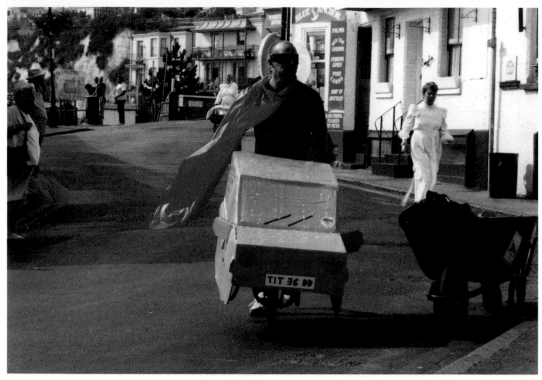

Wheelbarrow Race, Birchington, Kent, 2002 (photo: Dan Bass)

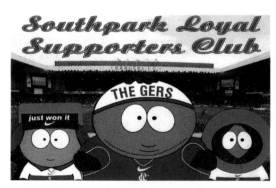

South Park Rangers Print, Glasgow, 1999

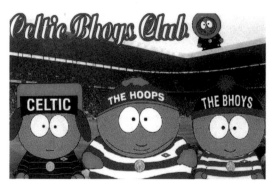

South Park Celtic Print, Glasgow, 1999

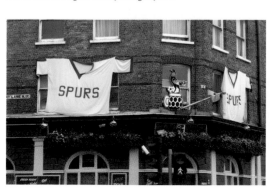

Pub Decoration, Tottenham, London, 2003

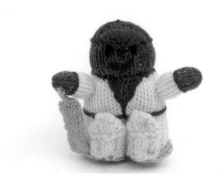

Knitted Cricketer, London, 2003

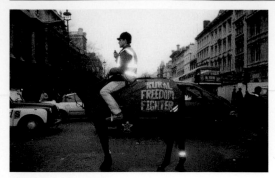

Farmers' Protest, London, 2001

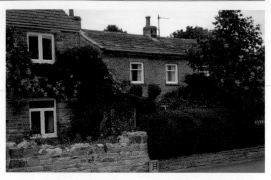

Topiary Animal, near Kirby Lonsdale, Lancashire, 2004

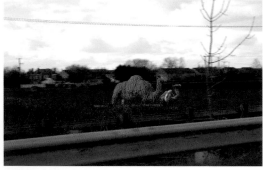

Camels Roadside Sculpture, M5 Motorway, near Bridgewater, Somerset, 2004

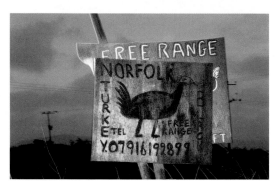

Turkey Sign, near Gloucester, 2004

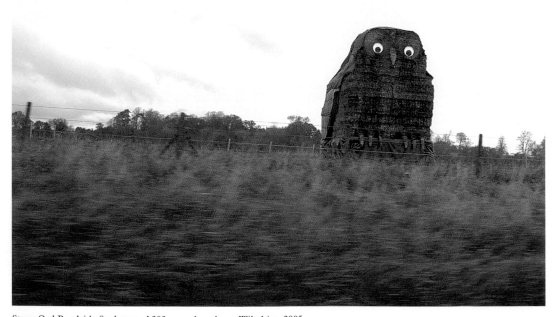

Straw Owl Roadside Sculpture, A303, near Amesbury, Wiltshire, 2005

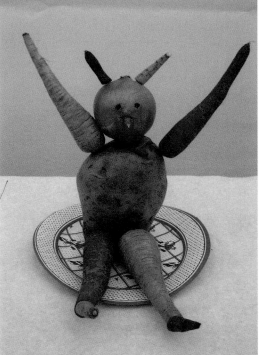

Vegetable Animal by May Davidoff-Grey, Lambeth Country Fair, London, 2004

Vegetable Animal by G.H. Ghent, Lambeth Country Fair, London, 2004

Vegetable Animal by Brenda Wheeler, Lambeth Country Fair, London, 2004

Vegetable Animal by Louise Guillaume, Lambeth Country Fair, London, 2004

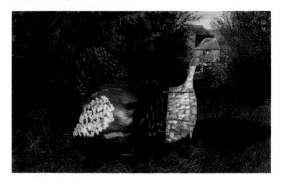

Turkey Sculpture, near Banbury, Oxfordshire, 2001

Dog Pin Cushion, London, 2000

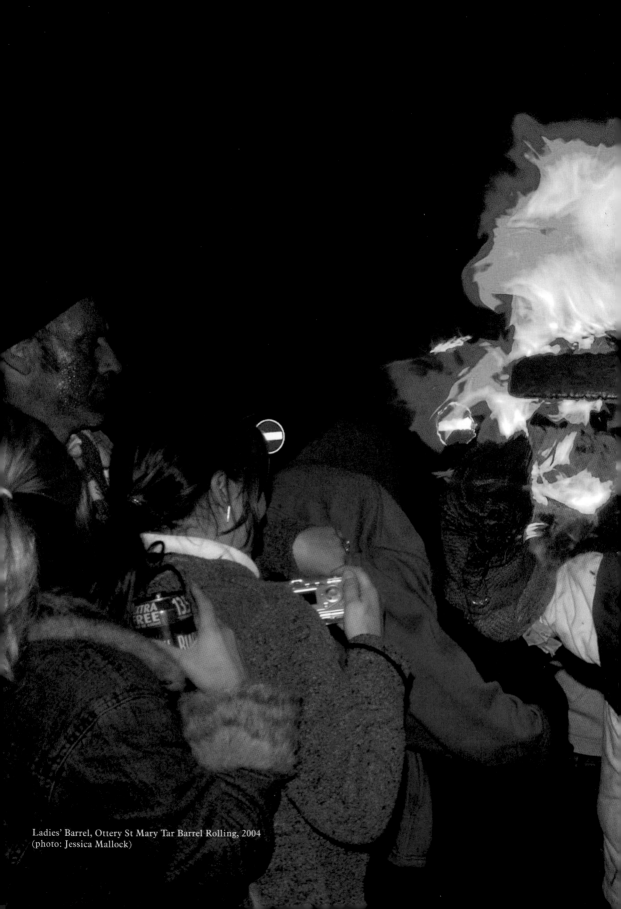

Ladies' Barrel, Ottery St Mary Tar Barrel Rolling, 2004
(photo: Jessica Mallock)

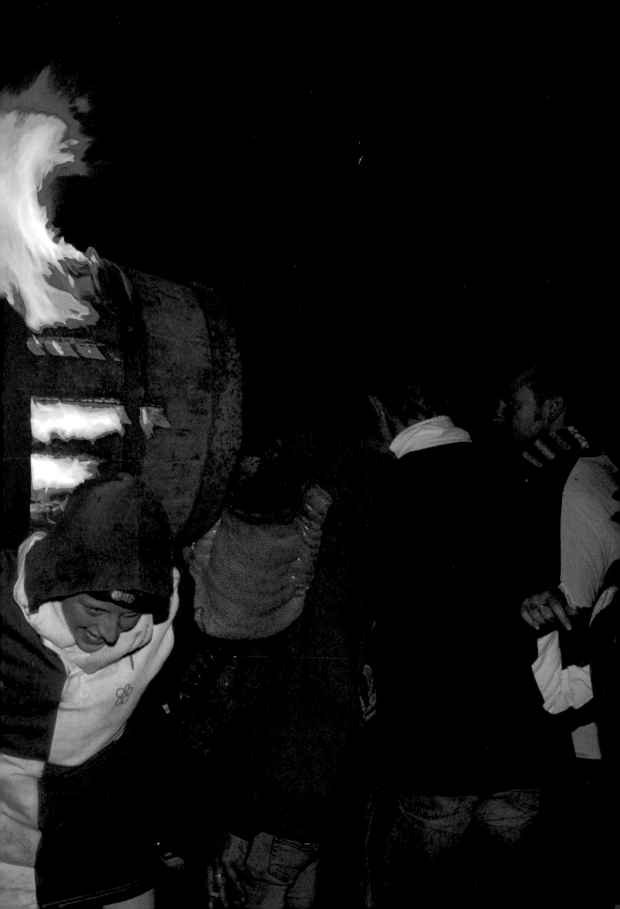

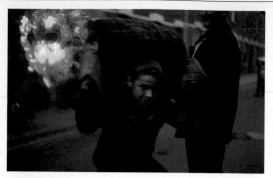
Children's Barrel (photo: Doc Rowe)

Sign (photo: Doc Rowe)

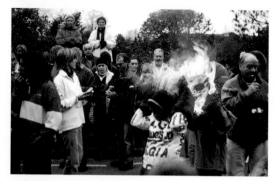
Boys' Barrels, 2004 (photo: Elaine Udy)

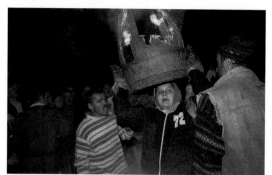
Sam Roland, Ladies' Barrel, 2004 (photo: Jessica Mallock)

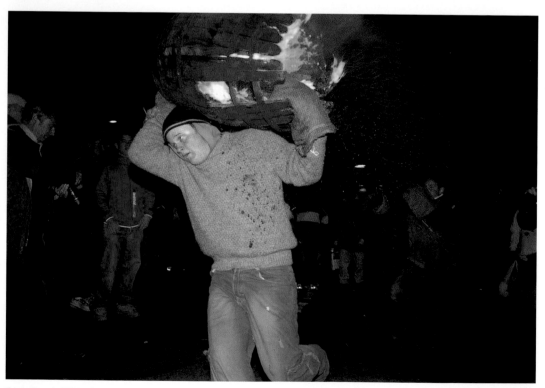
Boy's Barrel, 2004 (photo: Jessica Mallock)

Tar Barrel Rolling, Ottery St Mary

On November 5 each year since the 17th century the townsfolk of Ottery St Mary have taken to the streets with flaming tar barrels. Children's, Ladies' and Men's Barrels are successively set blazing and run through the town's crowded narrow streets. Proceedings culminate with the enormous Midnight Barrel ceremony.

Tar Barrel Roller, 2004

The Flaming Tar Barrel, 2004

The Midnight Barrel (photo: Jessica Mallock)

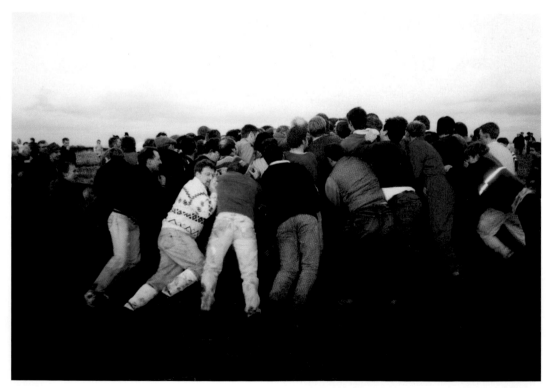

The Haxey Hood, Lincolnshire

'Hoose agan hoose
Toon agan toon
If tho' meet a man, knock 'im doon,
But don't 'Ut 'im!'

The Haxey Hood event happens on the feast day
of 6 January (twelfth night) in the village of
Haxey, Lincolnshire. The climax of the day is the
Sway Hood (that starts in a nearby field) in which
a leather baton (the Hood) is moved or swayed
competitively between three pubs in a scrum-like
fashion by hundreds of people. Leading up to the
Sway Hood is a well ordered series of events
including the Fool making a speech outlining the
rules of the game while a fire is lit underneath him.
At the end of the speech is a warning given to the
assembled players to which everyone joins in.

The Fool's Speech, Haxey, Lincolnshire (photo: Doc Rowe)

Swaying the Hood, Haxey, Lincolnshire, 2000

Burry Man, Queensferry

During the Ferry Fair held each August in Queensferry, Scotland, one of the local residents applies to the Council for the honour of being that year's Burry Man. The successful applicant dresses up in a full body costume made of flannel. This costume is then completely covered with the hooked fruits of Britain's two native Burdock plants. Whoever plays the part of the Burry Man must collect these 'burrs' along with other flowers and ferns to ornament his costume as well as the two staves he carries around on his journey.

(photo: Doc Rowe)

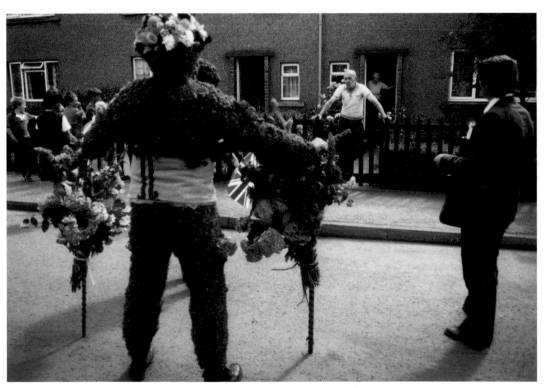

(photo: Doc Rowe)

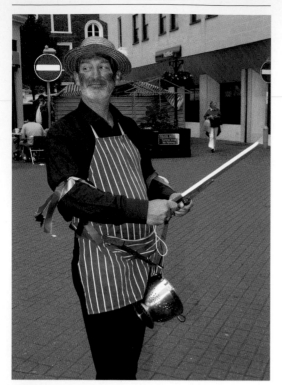

The Derby Tup

Here comes me an' ahr owd lass,
Short o'moneyan'shorto'brass:pay
For a pint and let us sup.
Then we'll show yer the Derby 'Tup'.

The Derby Tup also took place at Christmas time, and was a way to make money at a time of year when there was little work. The protagonists of the performances are a blacksmith (with hammer and tongs), a butcher (with knife and apron) and the Tup (a ram), who is slain.

The Butcher, Harthill Tuppers, Banbury, 2004

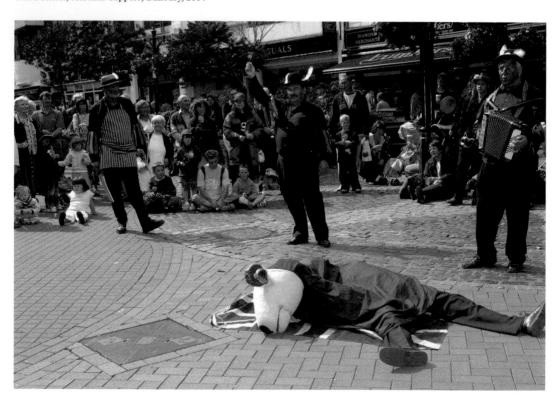

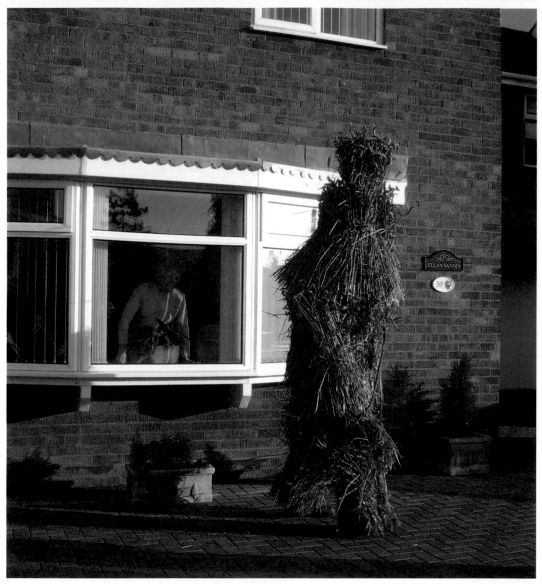

Straw Bear, Whittlesea, Cambridgeshire, 2003 (photo: Cathy Ward)

Straw Bear

Traditionally in Whittlesea, Cambridgeshire it was the custom to dress a man in the best straw and call him a 'Straw Bear'. He was made to dance in front of the townsfolk in return for gifts of money or beer and food. The tradition fell into decline at the end of the 19th century but was revived in 1980 by the Whittlesea Society.

Now the procession contains over two hundred and fifty dancers, musicians and performers from various parts of the British Isles, and includes street performances and Mummers plays.

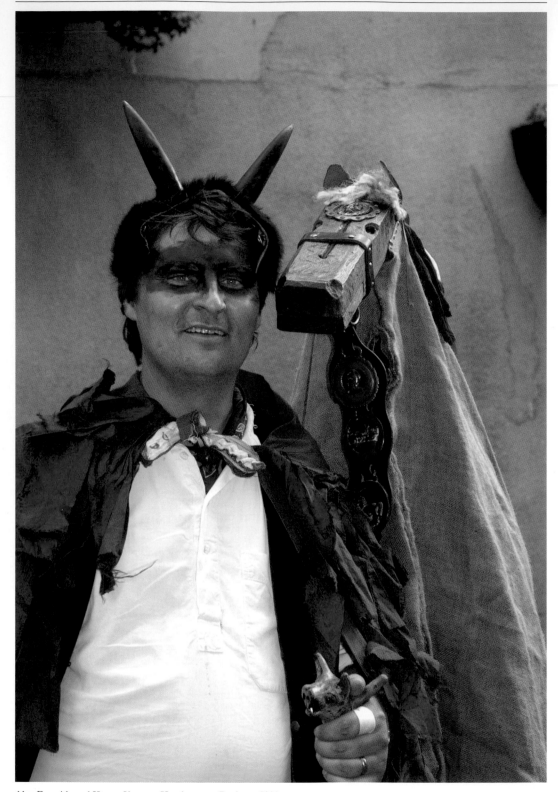

Alex Fernside and Horse, Sheppey Hoodeners at Banbury, 2004

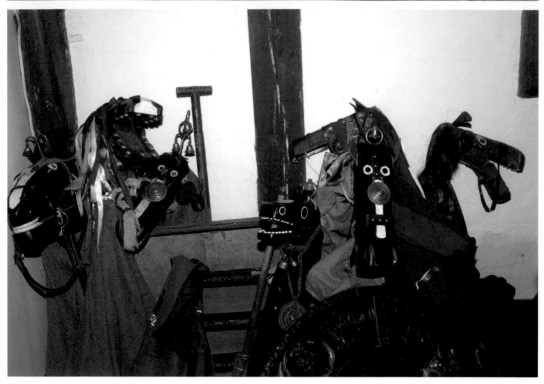

Hooden Horses at Simple Simon's, Canterbury, Kent, 2004

The Hoodeners

'The Hooden Horse is a strange beast peculiar to
Kent. Other than its antiquity, almost nothing is
known of its origins. Usually only seen after dark,
in midwinter, it has terrified many generations
of children, and not a few adults encountering
it unexpectedly on their doorsteps of a winter's
evening.' — M.S. Lawson, Waggoner

Hoodening is a custom based on performing a
humorous play along the theme of death and
resurrection. Most Hoodening groups appear to
have connections with Morris teams, and as such
are often associated with music and drinking
good beer. The characters usually include:
a Hooden Horse, or Dobbin; a Waggoner called
Joe or 'arry, who carries a whip and keeps the
others in line; a Mollie played by a man; Sam,
a lazy farm labourer; a member of the audience
who is often enlisted to ride the horse; and a
Musician to aid with the musical finale.

Hoodening Postcard

Whitstable Hoodeners, Kent (photo: M.S. Lawson)

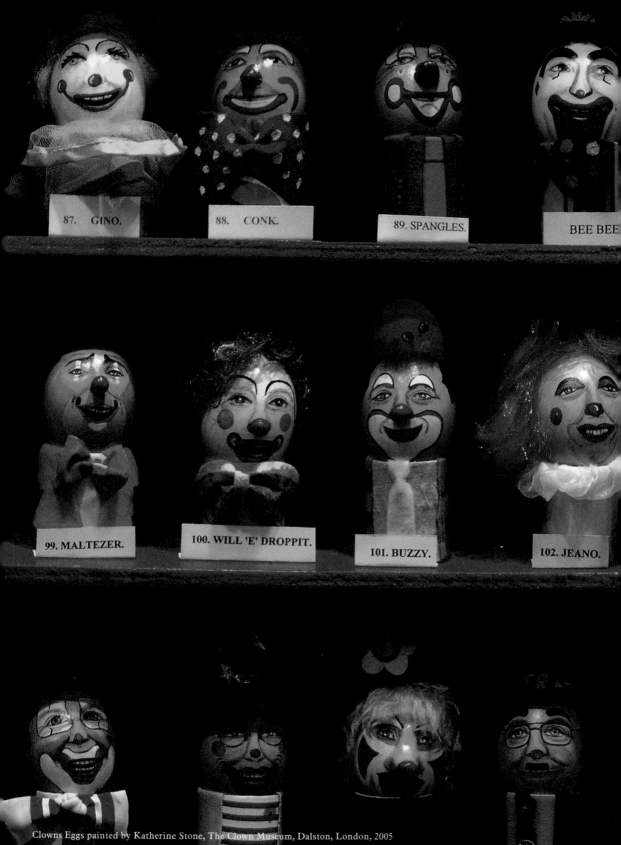

87. GINO.

88. CONK.

89. SPANGLES.

BEE BEE

99. MALTEZER.

100. WILL 'E' DROPPIT.

101. BUZZY.

102. JEANO.

Clowns Eggs painted by Katherine Stone, The Clown Museum, Dalston, London, 2005

111.PEPE

112 .JULIAN THE JUGGLER

113 REVILO

114.RAZZ

92. FLOSSIE CLOWN

93. SHAMMIE. (U.S.A.)

103. MR WOO.

104. VERCOE.

105. BOZETTE

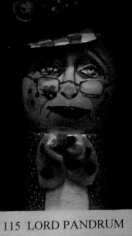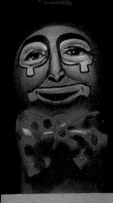

AUNTIE PEARL

115 LORD PANDRUM

116 MR. CUSTARD

The Clown Service, Dalston

The Clown Service at Holy Trinity Church, Dalston, London is a celebration of the life of the clown Joseph Grimaldi (1778–1837) and is attended by clowns from all over Britain.

Clowns have their faces painted onto eggs as a way of registering their make-up. The eggs are then kept at the Clown's Gallery in Dalston, a museum dedicated to the history of clowning, run by Clowns International.

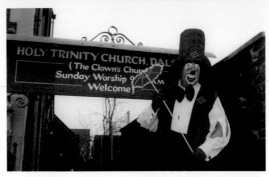

Tofi outside Holy Trinity Church, Dalston, 2004

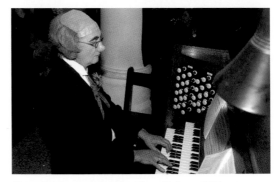

Clown Service Organist Alyn Forte, Dalston, 2005

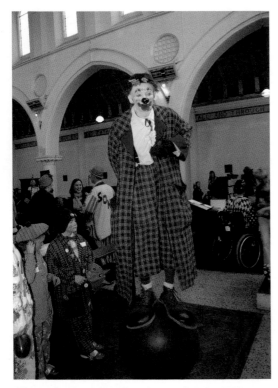

Rainbow the Clown, The Clown Service, Dalston, 2005

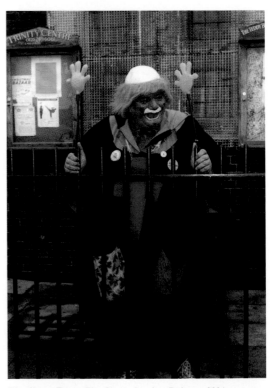

The Clown Fryer, The Clown Service, Dalston, 2004

POETS OF THEIR OWN AFFAIRS

A Brief Introduction to Folk Archive

Jeremy Millar

It is hardly common, these days, for a poet's words to provoke consternation yet Don Paterson's delivery of The TS Eliot Lecture at the end of October 2004 achieved this rare feat. While his criticism of Harold Pinter's war poetry attracted the greatest attention, disquiet was also felt at his attack on the writing of amateur poets, which has been encouraged by 'silly workshop exercises' and 'ultra-"accessible" poetry programmes'. 'The result of this inadvertent democratisation of the art,' he continued, 'has been many people feeling that armed with a beer-mat, a pencil, and a recent mildly traumatic experience they are entitled to send one hundred pages of handwritten drivel into Faber or Cape.' To counteract this tendency, Paterson declares it necessary to 'resurrect a guild that, I believe, would soon find it had some secrets worth preserving.' After all, '[o]nly plumbers can plumb, roofers roof and drummers drum; only poets can write poetry.' One might add: only artists make art.

Were we to ignore the tautologous circularity of his assertion for one moment, we would still be compelled to enquire as to how the role of poet might be defined, and, indeed, who might define it. 'Poet' was but one word — along with 'imagination', 'genius', and 'sublime' — that came to be redefined by William Wordsworth and Samuel Taylor Coleridge in and around the writing of the *Lyrical Ballads*, and in many ways it is the most audacious of their re-evaluations.

> Oh! Many are the Poets that are sown
> By Nature; men endowed with highest gifts
> The vision and the faculty divine

As George J. Leonard has noted, Wordsworth was to repeat this final line at the end of the 1815 Essay Supplemental, and would rest the value of his poems upon it, yet here the narrator is describing men 'wanting the accomplishment of verse'. However, these men are not only poets, but 'men endowed with highest gifts'. In Wordsworth's daring redefinition, the poet need no longer even write poetry.

One might usefully consider such matters upon returning to our own age, and the cultural activities represented within Jeremy Deller and Alan Kane's *Folk Archive*. No doubt one of the events which most offended Paterson's poetic sensibility in recent years was the 'outpouring' of verse which marked the death of Diana, Princess of Wales. It is interesting to note that not only were such tributes included in a video introduction to *Folk Archive*, but also, given Paterson's comment that 'amateur artists ... don't think they should exhibit at the Tate', that this video from *An Introduction to Folk Archive* was indeed shown at Tate Britain in 2000, and in an exhibition called *Intelligence* to boot. For the moment, let us just remember an important point made by Deller and Kane in their preface: what unites the diverse elements within *Folk Archive* is that they have been created 'by individuals who would perhaps not primarily consider themselves artists'.

The reasons for this belief are no doubt as many and varied as the people who hold it, although we might discern some common reasons. Perhaps, like Wordsworth's poets 'wanting the accomplishment of verse', lacking what is expected of them, the artists of *Folk Archive* perceive a deficiency of their creative talent, 'Which, in the docile season of their youth / It was denied them to acquire, through lack / Of culture and the inspiring aid of books'. It is this perception, Deller and Kane seem to suggest, which is at fault, rather than the talent itself. That these artists do not consider themselves as such, one might suggest, is because they have not been considered as such by others.

So perhaps we might now usefully consider, albeit briefly, the shifting definitions of art, the artist and, importantly, folk art. While definitions of what constitutes both 'art' and 'folk art' are necessarily subjective, and subject also to the changing contexts in which they might be considered, in one important sense they have traditionally been held in contradistinction: folk art is what art is not. As a 1976 review of the exhibition and book *The Flowering of American Folk Art 1776–1876* plainly

states: 'Since no two specialists in Europe and America can agree on exactly what folk art is, the authors simply made their selection outside the territories held by the scholars and collectors of fine arts and academic artists.' Of course, such a position is dependent upon a wilful — and no doubt wholly necessary — ignorance of the art scholarship and artistic practice of the twentieth century. It is not even that what might be termed 'traditional' forms of folk art have been ignored by the arts establishment. To take but a single institution, the Whitechapel Art Gallery, its identity firmly rooted in its traditionally working class location, has on numerous occasions displayed folk or popular art, such as the *Design and Workmanship in Printing* exhibition of 1915, one of a number of 'trade' shows that emerged from an 'Arts and Crafts' tradition and that were targeted at future apprentices; *Black Eyes and Lemonade — A Festival of Britain Exhibition of British Popular and Traditional Art*, an early Arts Council exhibition of 1951; *Banner Bright — An Exhibition of Trade Banners from 1821 to 1973*; and *The Fairground* in 1977, which was 'respectfully dedicated to the showmen and showwomen who maintain and transport the travelling fairs, and to the craftsmen who support them'. In her introduction to the catalogue for *Black Eyes and Lemonade*, Barbara Jones admits: 'We have not been able to find a satisfactory brief and epigrammatic definition of Popular Art. It was finally decided to set up a series of arbitrary categories which reflect most forms of human activity without creating bogus sociological implications.' The primary sociological implication of this exhibition in its entirety, however, like that of other elements of the Festival of Britain (such as the Lion and Unicorn Pavilion), in Jones' *The Unsophisticated Arts*, or in Enid Marx and Margaret Lambert's notable book, *English Popular Art*, all appearing in the same year, is a desire to consolidate a sense of Englishness following the ravages of war. Yet it is a sense of Englishness that is curiously backwards-looking. In the catalogue introduction to the exhibition of popular art they organised at the Museum of English Rural Life, Reading, in 1958, Marx and Lambert write:

> The term 'popular art', though we may none of us find it entirely satisfactory ... has the merit of being sufficiently elastic to include not only handicrafts and things made,

> either by professionals or amateurs in the country-side itself but also such things made to country needs and tastes, in towns and by machinery, or even imported from abroad.

It is striking to recall that, contemporaneous with these books and exhibitions, a new form of 'popular' art was being developed in England by members of what became known as the 'Independent Group', a form which was far more modern and internationalist in spirit. Appropriately, perhaps the most memorable display of these elements was made within the Whitechapel Art Gallery in the 1956 exhibition *This is Tomorrow*, the catalogue of which included Richard Hamilton's now iconic 'pop' collage, *Just what is it that makes today's homes so different, so appealing?* Indeed, just a few months later, in a famous 'Letter to Peter and Alison Smithson', Hamilton was able to find 'the brief and epigrammatic definition of Popular Art' that had eluded Jones a few years previously:

Pop Art is
Popular (designed for a mass audience)
Transient (short-term solution)
Expendable (easily forgotten)
Low Cost
Mass produced
Young (aimed at youth)
Witty
Sexy
Gimmicky
Glamorous
Big business

If, as Deller and Kane state, a primary aim of *Folk Archive* is 'to question what might constitute present day folk art', then this is but the latest expression of an ongoing process of re-evaluation of which the Independent Group were also a part. It is telling that such a process remains necessary. Even in more recent publications than those referred to above, such as the catalogue of the *British Folk Art Collection*, published in 1993, or James Ayres' *British Folk Art* of 1977, the area of enquiry seems to be curiously moribund, contrary to the stated intentions of the authors (indeed, the reader may be reminded of Raymond Williams' wry observation that 'sepulture' is one of only two words which rhymes with culture). While Ayres acknowledges, for example, that 'Industrialisation did not arrest the growth

of folk art', citing the painted roses of the canal boat, or the wooden steam-driven roundabouts which were often carved by ex-ship carvers made redundant by the development of new iron-hulled — and steam-driven — ships, his survey scarcely goes beyond 1900, 'when folk art was finally succumbing to industrialisation and to the destruction of the sub-cultures on which its traditions rest'. More than this, Ayres ends his foreword to the book with a curiously moralistic statement: 'Today we view this work as the product of a Garden of Eden before The Fall.'

What we are able to discern in such publications, I believe, is a thinly disguised contempt for that which they are ostensibly celebrating. It is certainly easy to find many items of traditional folk art 'quaint' or 'charming', their simple elegance enhanced when displayed in restored schoolhouses or the Regency townhouses of Bath, for example. By contrast, folk art from the post-lapsarian world of the twentieth and twenty-first centuries is deemed irredeemable. What was popular is now just common, the 'people's baroque' become merely vulgar. The passing of time allows those who wish to demonstrate their enthusiasm for 'the art of the people', without the blasted inconvenience of having to associate with them.

'The operational models of popular culture cannot be confined to the past, the countryside, or primitive peoples,' wrote the French theorist Michel de Certeau in his book *The Practice of Everyday Life*, 'They exist in the heart of the strongholds of the contemporary economy.' Indeed, what has come to be known as folk art shares much with what has come to be known as everyday life, and they are often similarly defined as that which escapes or lies outside specialised activities. Yet despite the enormous interest in exploring what might be understood as — and meant by — everyday life over recent decades, there seems not to have been concomitant developments in our understanding of folk art. Indeed, while the investigations of sociologists such as de Certeau, Pierre Bourdieu and, importantly, Henri Lefebvre, amongst many others, have demonstrated with immense power the complex relationships which make up something as seemingly simple as 'everyday life', many writers on folk art, and certainly those referred to here, require of it a straightforward truthfulness, a transparent expression, unaffected by self-conscious artistry, which delivers to the viewer a shared understanding of the world outside and the life that can be lived within it. One hardly need be aware of the many developments within twentieth century anthropology, ethnography, philosophy, even art history, to recognise the gaping conceptual hole that lies at the heart of such a desire, and the myth of authenticity that has been constructed around it like a piteous disguise: one need only ask, whose everyday life?

Of course, one might ask of this question in turn: well, who's asking, and why? Such are the difficulties of any enquiry into the nature of everyday life and its cultural practices, although they do hint at why ethnography has been so concerned at examining its own status and methodologies over the past century. The art critic Hal Foster has referred to an 'artist envy' within critical anthropology in recent decades, in which the artist has become 'a paragon of formal reflexivity, a self-aware reader of culture understood as text'. Foster notes also a complementary 'ethnographer envy' within some contemporary artistic practices. Often this can be found, with varying degrees of seriousness, within Conceptual Art, which often played with bureaucratic or statistical modes of expression, such as Dan Graham's *Homes for America* article from 1966, or the *ad absurdum* attempt by Douglas Huebler to photograph every human being. Of course, both Deller and Kane are well aware of the uncertain nature of the position in which they find themselves, or rather, have positioned themselves, as both artists and anthropologists, and also between the two. As the anthropologist Edgar Morin noted of the sociological observer (and one might say of the artist, or curator, similarly): 'he [sic] must be like everyone else and also the possessor of special knowledge like the priest and the doctor. The art of sociological inquiry is to experience this dual personality internally and express it externally, to dialectically enrich participation and objectification. We do not claim to have succeeded; we do claim that it is necessary to attempt to do so.' These are claims, no doubt, that Deller and Kane would also make.

Indeed, as Foster has made clear in his essay, 'The Artist as Ethnographer', questioning the authority of the ethnographically-minded artist is as important as the questioning of the artistic ethnographer. At its worst, such an artistic practice, like that of the folk art historians discussed earlier, is dependent upon a form of neo-primitivism,

in which the object of enquiry (or 'other', in contemporary terms) is remade as somehow 'authentic' or 'real', and yet in its very naivety dependent upon the more sophisticated practice in order to draw out its immanent self-identity. As de Certeau might have it, such a practice is merely an 'offering up of hagiographic everydayness for its edifying value'. Of course, what we then become increasingly aware of is the act of speaking for others, in which, according to critic Grant Kester, the community artist is in a position analogous to that of the delegate (as defined by Pierre Bourdieu), as someone who speaks on behalf of a certain community or group. This relationship is not a simple one, however, as not only does the delegate derive their legitimacy from the community for which they speak, this community is in some sense created — at least symbolically — through the expression of the delegate. It is upon this understanding that Kester questions 'the rhetoric of community artists who position themselves as the vehicle for an unmediated expressivity on the part of a given community'; indeed, certain collaborative community artists, he claims, operate as little more than self-serving delegates that claim 'the authority to speak for the community in order to empower [themselves] politically, professionally, and morally'.

It should be clear that this is not a charge that I think could be made, at least not fairly, at either Deller and Kane or *Folk Archive*. In many discussions of the artist-ethnographer, or community artist, the community being spoken for are said to possess both a curious ability, and a curious lack of ability also; that is, they possess an authentic voice and yet somehow lack the means of articulation. The artist not only helps the community find its voice, but also trains it, before projecting it into the world. What is important to bear in mind with *Folk Archive* is that the works included were made quite specifically for forms of public display no matter how diverse, or different from the context in which we now come across them, and are not simply objects or activities that have been taken from a hidden corner of everyday life and that now stand, rather awkwardly, for our attention. Everything included within *Folk Archive* is quite clearly the result of a self-consciously creative activity, and not a raw self-expression, to be appreciated for its guileless charm.

Furthermore, and perhaps even more importantly, *Folk Archive* does not perpetuate — or even allow for — any coherent sense of what might be meant by community, although many different communities are represented. For some, the community identity is strong and almost necessarily univocal, and the works on display reflect that, such as the unionist and nationalist murals, or the trade union banners; for others, the communities consist of people who would, no doubt, rather not be a part of them, such as prison inmates. Community is here understood as something provisional, and subject to competing claims, social forces and misunderstandings, a community that is 'inoperative', to use Jean-Luc Nancy's term. And if a coherent — and unchanging — understanding of community is impossible, then so too must any representation of it, which is why, importantly, *there is no such thing as the Folk Archive*. Rather, it is as a concept instead of a material fact, an actively organising (and disorganising) idea instead of a passive accumulation of objects, that it is able to represent more accurately the cultural productions of contemporary communities, rather than being hampered by any perceived lack of methodological rigour. Indeed, *Folk Archive* might even answer anthropologist Michael Taussig's call for 'an understanding of the representation as contiguous with that being represented and not as something suspended above and distant from the represented.' In so doing, *Folk Archive* not only provides us with an invaluable picture of life in Britain today, it shows us also what life might be.

— James Ayres, *British Folk Art*
(London: Barrie and Jenkins Ltd, 1977)

— Yvette Biró, *Profane Mythology —*
The Savage Mind of the Cinema
(Bloomington: Indiana University Press, 1982)

— *British Folk Art Collection* (London:
Peter Moores Foundation, 1993)

— Michel de Certeau, *The Practice of Everyday Life*
(Berkeley: University of California Press, 1984)

— Hal Foster, *The Return of the Real*
(Cambridge, Mass.: The MIT Press, 1996)

— Ben Highmore (ed.), *The Everyday Life Reader*
(London: Routledge, 2002)

— Richard Hoggart, *The Uses of Literacy*
(London: Penguin Books, 1992)

— Miwon Kwon, *One Place After Another —*
Site-Specific Art and Locational Identity
(Cambridge, Mass.: The MIT Press, 2002)

— Henri Lefebvre, *Critique of Everyday Life:*
Volume 1 (London: Verso, 1991)

— Henri Lefebvre, *Everyday Life in the*
Modern World (London: Athlone Press, 2000)

— George J. Leonard, *Into the Light of Things —*
The Art of the Commonplace from Wordsworth to
John Cage
(Chicago: University of Chicago Press, 1994)

— Claude Lichtenstein and Thomas
Schregenberger (eds.) *As Found —*
The Discovery of the Ordinary
(Baden: Lars Müller Publishers, 2001)

— Nikolaus Pevsner, *The Englishness of English Art*
(London: Penguin Books, 1997)

— Alan Read, *Theatre and Everyday Life —*
An Ethics of Performance
(London: Routledge, 1993)

— *The Whitechapel Art Gallery Centenary Review*
(London: Whitechapel Art Gallery, 2001)

DIARY OF SELECTED EVENTS

January

Blessing of the Seas
Margate, Kent *Early January*

Haxey Hood Game
Haxey, Lincolnshire *January 5 or 6*

Straw Bear Festival
Whittlesea, Cambridgeshire
Friday and Saturday before Plough Monday

Plough Slots Service
Goathland, North Yorkshire
Monday after January 6

February

Clown Service
Holy Trinity Church, Dalston, London
First Sunday in February

Jorvik Viking Festival
York, North Yorkshire *Entire month of February*

March

Pancake Day Race
Olney, Buckinghamshire *Shrove Tuesday*

Shrovetide Football
Ashbourne, Derbyshire *Shrove Tuesday*

Shrovetide Skipping
Scarborough, North Yorkshire *Shrove Tuesday*

April

April Fool's Day Practical Joke
Birchington, Kent *April 1*

Midgely Pace Egg Play
Calder Valley, West Yorkshire
Good Friday

Nutters Dance
Bacup, Lancashire *Easter Sunday*

Easter Parade
Battersea Park, London *Easter Monday*

Hare Pie Scramble and Bottle Kicking
Hallaton, Leicestershire *Easter Monday*

Northumbria Gathering
Morpeth, Northumbria
Week after Easter

Spring Flower Show
Harrogate, North Yorkshire *Late April*

Wray Scarecrow Festival
Wray, Lancashire *Late April*

May

May Day
Padstow, Cornwall *May 1*

May Morning Ceremony
Oxford *May 1*

Mayday Trade Union March
Clerkenwell, London *May 1*

Minehead Hobby Horse
Minehead, Devon *May 1–3*

Jack in the Green
Hastings, Kent *May 1*

Royal May Day Celebration
Knutsford, Cheshire *First Saturday in May*

Flower Parade
Spalding, Lincolnshire *Early May*

Furry Dance
Helston, Cornwall *May 8*

Garland Day
Abbotsbury, Dorset *May 13*

Woolsack Races
Tetbury, Gloucestershire
Spring Bank Holiday

Hooden Horse
Charing, Kent *Spring Bank Holiday*

Hunting the Earl of Rone
Combe Martin, Devon *Spring Bank Holiday*

June

Scuttlebrook Wake
Chipping Campden, Gloucestershire
Saturday after Spring Bank Holiday

Appleby Horse Fair
Appleby, Cumbria
Second Tuesday and Wednesday in June

Barton Mills Scarecrow Festival
Barton Mills, Cambridgeshire *Mid June*

Banbury Hobby Horse Festival
Banbury, Oxfordshire *June or early July*

July

Tynwald Day
Isle of Man *July 5*

Bastille Day, Maison Bertaux
Soho, London *July 14*

Tweedmouth Salmon Feast
Tweedmouth, Northumberland
Sunday following July 18

Tolpuddle Martyrs Procession
Tolpuddle, Dorset *Third Sunday in July*

Durham Miners Gala
Durham
Saturday in the second week of July

August

Royal National Eisteddfod
Alternates between north and south Wales
First week in August

Priddy Sheep Fair
Priddy, Somerset *Mid August*

Burry Man
Queensferry, near Edinburgh
Mid August

Grasmere Sports
Grasmere, Cumbria
Closest Thursday to August 20

Burning of Bartle
West Wilton, North Yorkshire
Closest Saturday to August 24

Plague Sunday Service
Eyam, Derbyshire
Last Sunday in August

Notting Hill Carnival
Notting Hill, London *August Bank Holiday*

September

Hop Hoodening
Canterbury, Kent *Early September*

St Giles Fair
Oxford *First full week in September*

Horn Dance
Abbots Bromley, Staffordshire
*Wakes Monday, the first Monday following
first Sunday after September 4*

Blackpool Illuminations
Blackpool, Lancashire
Early September to early November

Egremont Crab Fair
Egremont, Cumbria
Closest Saturday to September 18

Painswick Church Clipping
Painswick, Gloucestershire
Third week in September

Sowerby Bridge Rush-bearing
Sowerby Bridge, West Yorkshire
Early September

Pewsey Carnival & Torchlight Procession
Pewsey, Wiltshire
Fourth week in September

October

Nottingham Goose Fair
Nottingham *Early October*

Tavistock Goose Fair
Tavistock, Devon *October 10*

Pack Monday Fair
Sherborne, Dorset
First Monday following October 10

Border Shepherds Show
Alwinton, Northumberland
Second week in October

Stratford Mop Fair
Stratford-upon-Avon, Warwickshire
Mid October

Taunton Illuminated Carnival
Taunton, Somerset
Third week in October

Punkie Night
Hinton St George, Somerset
Last Thursday in October

Oyster Proclamation & Feast
Colchester, Essex
Last Friday in October

Antrobus Souling Play
Antrobus, Cheshire
October 31 and first two weeks in November

November

Tar Barrel Rolling
Ottery St Mary, Devon *November 5*

Lord Mayor's Show
Guildhall to The Strand, London
Second Saturday in November

Torchlight Procession
East Hoathly, East Sussex
Early November

Traditional Bonfire Celebrations
Edenbridge, Kent *Early November*

Guy Fawkes Night
Throughout the UK *November 5*

Turning the Devil's Boulder
Shebbear, Devon *November 5*

Hatherleigh Fire Festival
Hatherleigh, Devon
First Wednesday after November 5

Firing the Poppers
Fenny Stratford, Buckinghamshire
November 11

December

Greatham Sword Dance
Greatham, Cleveland *December 26*

Allendale Tar Barrel Ceremony
Allendale, Northumberland
New Year's Eve

Mari Lwyd
Llantrisant, South Wales
Around Christmas and New Year

Folk Archive:
Contemporary Popular Art from the UK

Jeremy Deller and Alan Kane
Published and distributed by Book Works

Copyright 2005 © Jeremy Deller, Alan Kane
and the artists; Jeremy Millar for his text

Second edition printed in 2005
ISBN 1 870699 81 5

Co-ordinated and edited by Bruce Haines
Assistant editor: Kim Dhillon
Designed by James Goggin / Practise
Printed by Die Keure, Bruges

Opus Projects: Opus 5

Book Works
19 Holywell Row
London EC2A 4JB
Tel +44 (0)20 7247 2203
Fax +44 (0)20 7247 2540
www.bookworks.org.uk

Thanks to:
Tasha Amini, Jessica Mallock, Annabel Rooker

Dan Bass, Dean Biggs, Deborah Blachard
and Alistair McKay at John Lewis Partnership,
Braithwaite School, Ian Charlesworth,
Circlemakers.org, the Clare Family, Steve Connoly
and Daniel Copley, Dave Crossley, Mike Dawson,
Sara De Bondt, Dave Douglass, the town of
Egremont, Felicity Greenland and the English
Folk Dance and Song Society, Ed Hall, Tom and
Alf Harrington, Stuart (Sam) and Val Hughes
of Bikeart.co.uk, Niki Kallis, Mark Lawson, Pat
Lumsdale and the National Federation of Women's
Institutes, the staff of Maison Bertaux, Marti,
Fee, Kevin and Keith from Hastings, Mattie the
Clown and Clowns International, Tommy
Mattinson, Ralph and Rob Merritt and the Crab
Fair Committee, Clive Miles and Ellie Cooke,
Alan Newman and Stuart Johnson, Matthew
Redman, Roger Robson, Bill Ross, Doc Rowe and
Jill Pidd, The Rev Paul Sinclair, Sally Sarah Shaw,
Lynn Setterington, Mick Tems and Pat Smith,
Elaine Udy, University of the Arts London,
Amanda Wait, Cathy Ward and Eric Wright,
Julie and Graham Whitley, Elva Wilkinson, Jessica
Wythe and all the contributing artists from
prisons, young offenders units and secure hospitals.

The book is published to accompany a touring
exhibition organised by Jeremy Deller, Alan
Kane and Bruce Haines from May 2005 to
September 2006. Tour venues include: Barbican
Art Gallery, London; Milton Keynes Gallery;
Spacex Gallery, Exeter; Kunsthalle Basel,
Switzerland; New Art Gallery, Walsall;
Aberystwyth Arts Centre and The Lowry, Salford.

This book is supported by Arts Council England
and The Henry Moore Foundation

The Henry Moore
Foundation

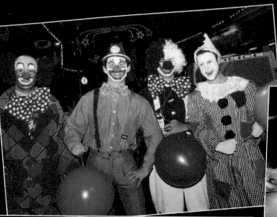

Happy n

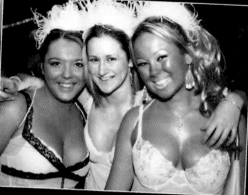

Photogra
Mel Bonf
and Bern
White joi
New Year
Eve reve
in Newqu
who don
dazzling
of costu
welcome
2005.

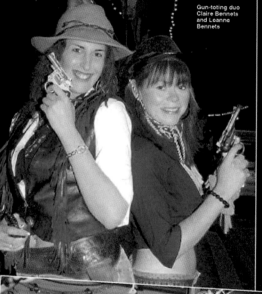

Gun-toting duo
Claire Bennets
and Leanne
Bennets

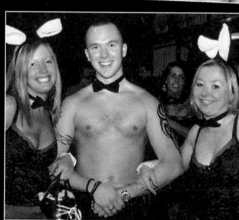

NEWQUAY'S st
laughter on Frid
thousands of re
variety of fancy
hit the streets t
New Year.

. Spirits were h
say there were
thousand peopl
Square at midni

Acting Inspec
said: "Spirits w
the town and th
any trouble.

"Not only did
increase in offic
seemed to be m
fancy dress!"

Pubs and club

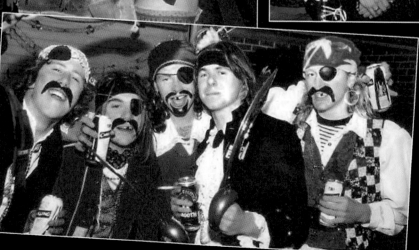